DROPS OF
NECTAR

SWAMI CHIDANAND SARASWATI

DROPS OF
NECTAR
TIMELESS WISDOM FOR
EVERYDAY LIVING

wisdom
tree

ISBN: 81-8328-021-8

Published by
Wisdom Tree
4779/23, Ansari Road
Daryaganj, New Delhi-2
Ph.: 23247966/67/68

Published by Shobit Arya for Wisdom Tree; *edited by* Manju Gupta; *designed by* Kamal P. Jammual; *typeset at* Icon Printographics, New Delhi-110018 and *printed at* Print Perfect, New Delhi-110064

Contents

Foreword

It is by the Lord's grace that you are holding this book in your hands. They say that a true saint is not one who is simply enlightened himself, but one who brings enlightenment to others. Swamiji is, therefore, one of the truest saints I know. His words, his life, his message and his *satsang* carry lakhs of people to directly communicate with God.

Swamiji is one of those rare souls whose life will have an enormous impact on humanity – today, tomorrow and in the future. He touches and transforms all those he meets. Yet, his divine influence extends infinitely further. He is not content with only serving those who come to him. Rather, he works tirelessly, yet silently and humbly, to serve every individual creature on the planet, ranging from cows on the streets to children in schools, to spiritual communities across the globe.

There are many saints who can impart divine teachings. But teachings are not enough. In order to truly inspire people, to touch and uplift the deepest corners of their soul, one must

have the divine touch. It is that touch that Swamiji possesses. So, what you have here in this book is not only the word of God; it is the touch of God.

Read this book, re-read it, then re-read it again. Let its message sink into every corner of your being. Then, if you are open enough to it, you will feel you have been touched by God.

Rameshbhai Oza (Bhaishri)

Introduction

I have been blessed beyond words to spend the last year-and-a-half living in Rishikesh and working with Swamiji. During this period I heard many people ask, "Isn't there any published compilation of Swamiji's ideas, his teachings, his wisdom?" The answer, much to my dismay, was, "No." The absence of such a work is grievous, for the wisdom that flows forth with his every breath is worthy of being immortalised.

On the auspicious occasion of the *Kumbh Mela*, in 1998, I took the opportunity to bring together as much 'nectar of wisdom' as I could. It is on this occasion that people come from every corner of the earth to bathe in the holy waters and imbibe the divine nectar of immortality. Yet, what is it that truly uplifts us, changes us, brings us closer to God? For me, it has been Swamiji's holy presence in my life. But how to encapsulate this divine wisdom and insight in a few pages? The task is almost impossible. Yet, while words are a poor substitute for his presence, they carry with them the essence of his teaching and his message.

I have, therefore, compiled as many of his written articles

(in English) as I could find. The articles come mainly from magazines which were published in the USA and in Europe for the Indian community living abroad.

In addition to the articles, there are stories, or rather parables, that I have heard Swamiji narrate. I have frequently been witness to occasions when someone would ask him a question to which he would not directly respond. Rather, on these occasions, his voice would take on an ethereal tone and his gaze would drift. He would say, "Let me tell you a story," and we all knew something extraordinary was taking place.

Then, on such occasions, when he had finished the story, he would explain its meaning. Hence, these stories contain two parts: the story itself and the lesson he gave afterwards. To me, these parables and lessons are like words spoken by God and which a mere mortal has attempted to capture on paper.

Therefore, the book has two tones: one is literary — writings which have been published in international magazines and newspapers, the other is oral — words which have been spoken. However, while the topics of the articles (or the plots of the stories) differ, the underlying essence of Swamiji's message remains the same. His message is, "Go to God."

"Go to God, be with God" is not only the message of his words; it is the message of his life. He is not only someone who endeavours to connect you to God; rather, he is someone whose mere presence carries you to God.

I would like to tell a story of my own. My story is not a parable meant to teach a lesson. It is a true and accurate

picture of the man behind the words in the following pages.

I reached Rishikesh in 1996 as a tourist. I was twenty-five-years old on a three-month vacation from my Ph.D. programme in California. How I met Swamiji and moved into Parmarth Niketan is another story, a beautiful example of God's divine plan. For now, it will suffice to say that I was there alone and planning to stay approximately one week. During my first two days at the *ashram*, on the banks of the Ganga, in Swamiji's presence, my entire being was transformed (and this transformation has not stopped yet). I was overflowing with joy, bliss and a serenity I had never known. At Ganga *aarti*, the world would disappear into the blazing fire, into the sea of voices as they sang, into the setting sun as it bounced off the waters, into the pervasive peace of Swamiji's presence.

So, on the second day, I went to Swamiji. We sat in his meeting room — he, a forty-five-year old renunciant, and I, a twenty-five-year old American girl who could barely see straight. "Swamiji," I said, 'I feel so incredibly blessed to be here, to have met you, to be able to spend this time on the banks of the Ganges. I feel like you have given me so much. Is there anything I can give you, anything I can do for you?"

A voice in my head that had spent twenty-five years being indoctrinated by the West yelled at me: *'What are you saying?'* After all, there we were, alone in his office. I had only known him for two days, and I had been warned in America to "stay away from Indian gurus".

Swamiji looked at me, the light streaming in through the windows, casting a brilliant halo around his head. "Anything?" he asked. The voice inside my head screamed, *'No, you're*

crazy!' Yet, the voice that actually flowed from my heart to my mouth said, "Yes, anything."

Swamiji paused. "You promise?" he asked, staring directly at me as though this was the most serious question in the world. I felt I would pass out from the intensity of the hold his eyes had on me. Every word I had heard in my psychology of mind-control classes, every story I had read about Indian gurus surrounded by naked women and fancy cars, and every rational thought I could have, came swimming to my brain, filling it with fear. *'Don't promise,'* the voices pleaded. I could hear my mother, at the opposite end of the world, saying *'Just get up and walk out.'*

Yet, my heart was calm and still, and filled with a sense of security that I had never known. "I promise," I said, knowing that I truly would give this man — whom I had known for two days and who was old enough to be my father — anything he asked for.

The intensity of his gaze lifted and his face broke into the lightest, purest smile I had ever seen. "Okay then, three things," he said. Even as the divine light continued to emanate from his face, I knew that what he was going to say would change my life forever. "First," he began, "get closer and closer to God. Second, serve the world. Even if it means doing without something you want or something you think you need, give it to humanity. Third, be happy. Give all your sadness, all your anger, all your bitterness to me. Give it to me and give it to the Ganga, but don't keep it in your heart. You must be happy."

I sat there in what felt like a far-off corner of the world,

in a place so beautiful that it could only exist in fairy-tales, in the presence of a man who wanted nothing else from me than to be close to God. The tears streamed down my face, though they were not tears of sadness. They were tears on having found the truth.

I could not have told you which was brighter — the morning sun blazing its way through the window or the light streaming from his eyes. I could not have said which was purer — the red rose, still covered with morning dew, which has just opened its petals to the world, or the love pouring forth from his heart. I could not have told you who was God — the formless Almighty Lord my Jewish upbringing had taught me to worship, or the small, simple man, draped in saffron robes, sitting in front of me.

Rishikesh **Sadhvi Bhagwati**

The Art of Meditating:
How to be a Yogi 24 Hours a Day

The ancient science of yoga was passed down from our *rishis*, saints and sages who derived divine inspiration while meditating on the Himalayas. Through their meditation, austerities and prayers, a treasure-chest of wisdom was bestowed upon them for the benefit of humanity.

Yoga is not a religion. It does not require us to believe in a certain God or to chant certain *mantras*. It is an ancient science which leads to health in the body, peace in the mind, joy in the heart and liberation of the soul.

These days people take yoga classes to learn all about the various techniques of *asanas*, of *pranayama*, of meditation. But yoga is more than that: it is a way of life and its teachings should penetrate every aspect of our being — from our actions to our speech and to our thoughts.

An *asana* session has a beginning and an end. You start at 8:00 for instance, and you finish at 9:00. Your *pranayama* has a beginning and an end. You start at, say, 6:00 and you finish at 7:00. Same is the case with meditation.

But, what about the rest of the time? How to live yoga even when we are not doing *asanas, pranayama* and meditation? How to practice *yoga* in the grocery store? How to live like a *yogi* in our family, in our workplace, when we are stuck in traffic?

Yoga is an eight-fold path. *Asana* is one part; *pranayama* is another; meditation is still another. Two other aspects of this path are called *yama* and *niyama*. These can be roughly translated as righteous living. These are the rules for life. By following these moral, ethical and spiritual guidelines, one's entire life becomes a yoga.

In general, *yama* is exercising restraint over our lower, baser, animal-like instincts by, for instance, overcoming greed, lust, anger and envy, and definitely never acting upon these impulses. *Niyama* can be seen as the embrace of higher, spiritual, humane values by, for instance, being generous and selfless, cultivating piety, devotion, compassion, loyalty and humility.

These moral and ethical principles affect us, whether we believe in them or not. People may say, "But, I'm not Indian," or "I'm not a Hindu, so I don't have to follow these ethical laws." However, this is not true. As I mentioned, yoga is not a religion. This means that *none* of the eight aspects depends upon one's spiritual belief system. Just as *shirshasana* is beneficial whether one 'believes' in it or not, similarly the moral and ethical laws of the universe affect us, whether we believe in them or not.

They are like the laws of gravity. One can certainly stand on top of a 10-storey building and say, "I don't believe in gravity so I am going to jump." Perhaps, as one falls through

the sky, one temporarily thinks one has succeeded in defying this pervasive law. Yet, inevitably, one will hit the ground and one's life-breath will be immediately whisked away.

Similarly, people may live lives full of greed, anger, lust, arrogance and disregard for their fellow human being for many years, thinking they are immune to these natural laws which affect us all. However, eventually, they too will hit the ground and be destroyed.

I remember, once when I was abroad, I saw a sign that said, "Follow the rules and enjoy your stay." It is like that with life as well.

There are so many things we do that perhaps we realise are not right, but we do them anyway. We lie, we covet things which are not ours: 'Oh, how I wish that beautiful car were mine instead of his.' We harbour bad thoughts about each other: 'Oh, if only he would fall sick, then I could get his job.' We deny these thoughts to ourselves or we rationalise them with excuses. However, if we are to live truly yogic lives, then we must subject every area of our life to scrutiny.

For example, is our diet in concert with a yogic life? I know that people are learning a lot about *sattvic* food, which means food that is fresh, easily digestible and leads to health of the body and peace of the mind. However, I simply ask, "Are you a vegetarian? Do you teach vegetarianism to your children?" There is virtually nothing we can do to our bodies that is more contrary to the yogic life than to eat meat. How can we be true yogis, if our bodies are graveyards for dead animals? How can we be at peace if our food choices bring pain and suffering to others?

Additionally, one of the most important aspects of yoga for daily life is honesty. How many of us can say that we do not deceive? We would very much like to believe that we are righteous, honest people and that we are passing these values on to our children. Well, if we eat meat, we cannot say that we do not deceive. As I have explained before here is why: if we wanted to be honest and still eat meat, we would have to go outside, chase down a live cow and bite right into it. Or we would have to go to one of those poultry 'farms', take the animal while it is alive, tear off its head, pull out its feathers and eat it raw.

Of course, we do not do that. Instead, we order a hamburger. We cannot even call it what it is, let alone kill it ourselves. So, we call it beef instead of cow. We call it pork instead of pig. We call it poultry instead of chicken. And we eat it packaged in neat, nice ways that allow us to forget what we are eating. How many people stop and think that the thing between the tomato and the bread on a hamburger used to be a living, breathing creature once? That it was someone's child?

A truly yogic life entails contemplation and introspection. We must ask ourselves, 'What right do I have to take the life of another?' We must pause and think about the decisions we make.

Additionally, a yogi is calm; a yogi is centred; a yogi is at peace, not in pieces. We cannot be calm and at peace if we eat meat. Let me explain: when animals (humans included) are threatened, we secrete large amounts of hormones. These hormones are frequently referred to as adrenaline. Their

purpose is to prepare our body to fight, to save our life. Have you ever noticed that when you get scared, a lot of things happen inside you? Your heart beats faster, your digestion stops, your palms sweat and your physical impulses become sharp. These are the result of the hormones. And they prepare us to either fight or run away. Thus, they are sometimes called 'fight or flight' hormones.

When an animal is about to be killed, its body is flooded with these stress hormones, which remain in the animal's tissues. So, when we eat these tissues, we ingest those hormones (which are the same as those that our own bodies make). This results in our bodies becoming flooded with these 'fight or flight' chemicals, making us even more prone to simple survival instincts. Thus, the saying, 'You are what you eat,' comes alive.

Additionally, how our food is prepared is as integral to our overall health and peace. The energy of preparation is absorbed into the food, and, just as the animal's stress hormones affect our bloodstream, we are physiologically affected by the energy of the cook and the place of preparation. Therefore, chant, sing and meditate while you cook and encourage devotion in those who cook for you. Eat pure, fresh food. Then, you will see the magic in it!

Let me explain how to let yoga saturate every aspect of your life. Remember, there is both *yama* and *niyama*. Yoga is not simply *yama*, or refraining from lower instincts. It is also *niyama*, the embrace of and adherence to higher principles and laws. But how to put these laws into daily practice? By adopting the following:

 5 The Art of Meditating

Meditation: Meditation is the best medication against all agitations. People have so many troubles today, mainly related to the stress in their lives. To address this anxiety, this sleeplessness, this inability to simply be content, they take pills or fill their lives with excessive material 'pleasures'. For example, when people feel stressed, they attempt to forget it by going to the movies or by getting drunk or by indulging in simple sensual pleasures. Yet, these are not permanent solutions. They do not address the underlying issues. They are simply band-aids to a wound that runs deep below the surface.

Meditation, on the other hand, will truly calm the mind, fill the heart with joy and bring peace to the soul; the serenity and joy last throughout the day and throughout your life. Meditation is not a simple diversion which works as long as we are actively engaged in it. Rather, meditation brings us in contact with God; it changes the very nature of our being. As we sit in meditation we realise the insignificance of whatever causes anxiety; we realise the transient nature of all our troubles; we realise the infinite joy and boundless peace that come from God.

Then let this meditation become a part of our life. Yes, of course, one should have a time set aside for meditation and there should be a quiet, serene place to meditate. All it requires is taking five minutes off at work to simply close our eyes, watch our breath, focus on the oneness of us all and connect with the Divine. Eventually, the goal is to let our life become meditation.

No Reaction: We must learn to be calm in our lives

and stay unaffected by all that happens around us. We must be like the ocean. The waves come and go, but the ocean stays. Even a large rock thrown from a great distance, with great force, will only cause temporary ripples in a small area. We must learn to be like the ocean that remains unaffected by these small, transient things.

So many times we act as though we are the waves of the ocean. Up one minute, down the next, changed by every gust of wind, by every passing boat. Yet, we are not these waves. I am using the analogy of the waves of the ocean, but we must realise that the waves I am really talking about are the waves of anger, anxiety, jealousy, greed and lust that are just as vast, just as strong and just as restless as the waves of the sea.

We act as though we are light bulbs and anyone who wants to can simply switch us on or off. Isn't it true? Can't the smallest comment or look or action of another change our mood completely? Isn't it so frequent that we are in a wonderful mood and someone at the grocery store is rude to us, or someone on the freeway overtakes us, or a friend is cold and distant? Any of these things can immediately switch our mood as though we were a light bulb.

How is that? How can one rude comment from a person have so much control over us? Are we so volatile in our emotions that others have more power over our moods than we ourselves do?

Aren't we more than this? Aren't we bigger, more divine, and deeper than this? Isn't there more to this human existence than the law of action and reaction? We must learn to keep

that light switch in our own hands and to give it only to God. Otherwise we are switched on and off, on and off, all day long and the only effect is that the light bulb burns out!

Let us take whatever comes as *prasad*, as a gift from God. Let us remain calm and steady in the face of both prosperity and misfortune. We must not lose our vital energy in this constant action and reaction to everything around us.

But how? How to remain unaffected by the waves of life? This is called spiritual practice! I always say that one of the best ways to learn 'no reaction' is through silence. When we are anxious, angry, tense or frustrated, we tend to say things which we later regret. So, let us learn the power of silence. Silence on the outside will lead to silence inside. That is why so many saints and other spiritual people observe 'silence time' for establishing contact with the Divine and charging their inner batteries.

So, let us learn to meet life's waves with silence — that will make 'no reaction' much easier to achieve.

There was once a huge elephant crossing a wooden bridge high above a raging river. The bridge was old and rickety and it shook under the weight of the elephant. As the elephant was crossing the bridge, he heard a voice. "Son, son," the voice called out. The elephant looked around him, but he was all alone. "Son, son," the voice continued. When the elephant reached the other side of the river, he saw a small ant crawl on to his nose. "Son," the ant cried, "we almost collapsed that bridge, didn't we? Our weight was so immense that the bridge almost collapsed beneath us, didn't it, son?"

Now, of course the elephant knew that the ant's weight

had been completely irrelevant to whether the bridge would have collapsed. And, of course, he knew that the tiny ant was not his mother. However, what good would it have done to engage in a battle of egos with the ant? Instead, the wise, calm elephant simply said, "You are right, Mother, our weight almost broke the bridge."

The elephant retained his serenity, peace and joy. And the ant, for what it was worth, was allowed to continue believing in its own greatness. But how many of us could be like the elephant? Aren't we always trying to prove ourselves to others? Aren't we always ready to shoot down anyone who trespasses on our egos?

Introspection: Begin the morning with meditation. All day practice 'no reaction.' And at night? Introspection. At the end of the day, a good businessman always checks his balance sheet: how much did he make, how much did he spend. Similarly, a good teacher reviews her students' test scores: how many passed, how many failed. In the same way, each night, we must examine the balance sheet of our day: what were our successes, what were our failures. And for all the successes, we must give credit to God. For, we have truly done nothing but let Him work through us. All credit goes to Him.

Just imagine if God had put one television screen on our foreheads and everything we thought was broadcast for the whole world to see — all our reactions, all our inner thoughts, judgements, weaknesses. We would never succeed nor would we have any friends! Isn't it true? So, it is by His grace that the world does not see our thoughts; only He sees our thoughts. For this, we can say, "Thank you, God, for all that went well today."

Our failures, we must also give to Him. The fault is ours, definitely, yet, He is so forgiving and so compassionate that He insists we turn these over to Him as well. We must say, "God, please take these minus points. However, you still love me and protect me against the world seeing all my minus points. I am so weak, but you protect me." In this way, each night we check our balance sheet, and we pray to God to help us have fewer minus points by making us stronger, better and more devoted.

If we practice these three things every day, then our lives will become more beautiful. Just as a serious daily *asana* practice can bring the glow of health to our body, a serious daily practice of meditation, no reaction and introspection can bring the glow of peace, joy and divinity to our lives.

Prayer is Faith; Faith is Love

We talk constantly about peace — peace between nations, peace in our societies, peace in our schools, peace in our families, peace within ourselves. Yet, this much desired peace continues to elude us.

How then can we attain it? What is the secret to finding this elusive treasure? We can spend millions of rupees to build posh downtown centres in our cities, but if we are at war with another country, they can bomb that centre to ashes in a second. We can spend thousands on building a beautiful home, but if our neighbourhood is violent, our windows will be smashed and our new lawns destroyed. We can work hard and be successful at our job, but if we come home to turmoil, there is no joy in the success obtained at work, for there is no one to share the joy with.

We can devote ourselves to obtaining high education, top credentials and a beautiful figure. However, if we are miserable inside, no outer achievement can ever pacify us.

So, the root to success in life — personal, familial, societal, national and international — is to first and foremost be at

peace. Yet, it seems that each day this peace slips further and further away from our hands.

Once, in Chicago, a woman came to see me. She was stressed and tense. She said that in order to sleep at night she took pills called Calmpose. I told her that she did not need to take them. "Just calm your pose," I said, "and you will sleep beautifully at night and be peaceful all day." If we are peaceful inside, humble inside, then nothing outside can ruffle us. So, the first message is, "Calm your pose and you will never need to take Calmpose."

However, instead of calming our pose, we frequently pose our calm! We want everyone to know how peaceful, serene and spiritual we are. Yet, all too frequently, that calm is superficial. We are not truly at peace inside.

The *mantra* of today seems to be 'I want peace'. Every day people tell me, "Swamiji, all I want is peace. Tell me how to find it."

First, let's talk about the 'I'. 'I' is one of the greatest obstacles to peace. 'I' is our ego. 'I' is our sense of ownership, doership and pride. This 'I' says, 'I want to be at the centre.' Isn't it true? We always want glory, appreciation, and prestige. Even when we don't do anything, we still want to be appreciated. This 'I' is responsible for our downfall.

Ideally, we must remove this 'I', which is dividing us from our own true selves, dividing families and dividing nations. Yet this is very difficult. Living in today's world, it is nearly impossible to completely remove the sense of 'me', 'mine' and 'I'. So the next best option is to take this 'I' and change it. How?

When 'I' stands vertically, it is an obstacle. It creates borders, barriers and boundaries between ourselves and others. But take this 'I' and turn it sideways to make it horizontal, and it becomes a bridge — between our families, our communities and our nations. Let this 'I' become a bridge in the service of the world. If we keep standing so straight and tall and proud as the vertical 'I', then we will always stand alone. If, however, we turn this 'I' sideways, we say, 'Okay, let me be a bridge, let me bridge chasms instead of creating them, let me stand smaller than others instead of always trying to stand the tallest, let me put others at the centre instead of myself.' This way we will stand united and peaceful.

We are so proud; this 'I' is so proud. 'Oh, I am so successful. I am so good.' But, the truth is that we only go to work, it is God who works. We can do nothing without His grace. One minute we are at our desks, acting like the king of the world. The next minute, one nerve, just one microscopic nerve in our brain fails and we can no longer speak or write. One small blockage in one tiny blood vessel and we cannot even go to the bathroom by ourselves. We must be fed and taken care of for the rest of our lives.

So, what is there to be proud of? It is He who makes us work. We just go to work. As soon as we realise this, then we can take our little 'I' and merge it with the big 'I', the universal 'I', the divine 'I'. Then, we can surrender our lives and our every action to Him. Then we can say, 'God, let my tiny drop of water merge with your great ocean. Let me be a tool for your will and your work.' It is through this selfless surrender to Him, that the pain of the 'I' is removed and our troubles and unrest disappear.

We must aspire to be like the sun. Look at the sun: it gives and it gives with no respite. The sun sets in India and we think, the sun has gone to sleep. But, if you call someone in America, he will tell you, "The sun is shining brightly." So, with no respite, the sun shines, giving light and life to all. And it makes no discrimination. It doesn't say, "I will only shine upon Hindus", or "I will only shine on Muslims, or upon Christians". No, the sun is there for all. The sun does not wait for you to pay your bills. If you don't pay your electricity bills for one month, the government turns off your electricity; but not so the sun. The sun never sends a bill.

We must be like that — always giving, without any discrimination and hesitation. That is the way to merge this 'I' with the divine 'I' and become peaceful and ever blissful.

So, first we merge this individual, obstructive 'I' with the divine 'I', and in doing so, we become free of the pride, ego and tension that block our attainment of peace. Then, we remove all our wants, our perceived needs and desires. They are obstacles to peace. The more we have the more we want. People always think that if they attain something more, whether it's more money, a better job, a degree, a good husband, then they will be happy. But, it never works like that. Happiness and peace are found not in acquisition, but rather in renunciation of our attachment. I always say, 'Expectation is the mother of frustration and acceptance is the mother of peace.' Wanting, yearning and expecting things never brings any lasting happiness.

The key to life is sacrifice. One of the most common Hindu rituals is a *yagna* fire. People sit around the fire and

make offerings to the fire. With each oblation to the *yagna* we say, "*Idam namamah.*" It means, 'Not for me, but for you.'

The purpose of this is to remind ourselves that although we may be performing the ritual for some benefit of our own, perhaps a wedding or the opening of a new business, we must remember that everything is for God. We must offer every thought, every action, every breath, at His holy feet. So, we must give more and want less. Then we will know true joy and peace.

But, how to become selfless? How to learn to give more? Prayer. Peace comes through prayer. It doesn't matter what name we use for God or what language we pray in. We can pray to Allah in Arabic, or we can pray to Jesus in English, or we can pray to Adonai in Hebrew, or we can pray to Buddha in Japanese, or we can pray to Krishna in Sanskrit. It is immaterial.

There was once a little boy who went to the temple with his father. He heard people reciting prayers in Sanskrit. They chanted different prayers, *mantras* and *slokas*. Then, at the end, the priest said it was time for a silent prayer. The little boy was nervous. He didn't know any of the prayers. But, he loved God and he wanted to pray to God. So he closed his eyes and he silently said, 'God, I don't know any Sanskrit prayers. I'm only a little boy. The only thing I know is the alphabet I learned in school. But, I know that all the prayers come from this alphabet. So, I will sing the alphabet and then whatever prayer you like best, you can make from this alphabet.' And he started to sing, "A, B, C, D, E, F, G..."

Let me tell you, God was happier with that little boy for

his devotion and purity, than with all the people who just pray like robots.

The point is: love God. It doesn't matter what name or form you use; it doesn't matter what language you pray in. Just pray, and then you will see the magic.

The fruit of prayer is faith. The fruit of faith is love. The fruit of love is devotion. The fruit of devotion is service. The fruit of service is peace.

Through prayer, faith, love, devotion and service, we will inevitably attain that sought-after state of inner peace. Then, when we are at peace inside, harmony will radiate out to all those around us, bringing peace to our relationships, peace to our community, to our nation and finally, to the world.

Heart at Peace; Mind at Ease

Every day people come to me with problems for which they seek guidance. While the details vary from person to person and situation to situation, there are common themes that run through much of what ails us. The deeper questions, the questions beneath the questions, are always the same: how can I be happy? How can I have meaningful relationships with others? Let me address a few important principles to live by.

Devote Life to God, not Glamour

Every day people go out to work, earn money and become more and more prosperous. Yet, at the end of the day, when they return home, they are not happy. At night, when they lie in bed to sleep, their hearts are not at peace, their minds are not at ease. There seems to be no correlation between the amount of money we earn, the number of possessions we buy and our sense of inner peace. Yet, if we ask people what they most deeply want out of life, they will say, "To be happy." How can we find this happiness that appears so elusive? What is the true secret to internal peace and everlasting joy?

The secret is God and God alone. In India, in every village, there is a temple. I remember when I was growing up, and it is true even today, the first thing everyone did in the morning was to go to the temple. Before beginning the day's tasks, people would visit the temple to pay obeisance to God and take three *parikramas* (walking in a circle) around God. The *parikrama* signifies: 'God, I am about to go out and perform my worldly tasks, but let me always keep you at the centre; let me remember that all work is for you.' Then, they would take *prasad* — from their tongues to their souls, God's sweetness would spread — and they would leave.

In the evening, before returning home, people would again visit the temple. 'God, if during this day, I have forgotten that you are at the centre of everything, please forgive me. Before I go home to my family, let me once again remember you, to whom my life is devoted.'

This occurs in almost every village daily. People in small villages have very little in terms of material possessions. Most of them live below the poverty line, yet, if you tell them they are poor, they won't believe you. This is because they have God at the centre of their lives. Their homes may not have TV sets, but they all have small *mandirs*; the children may not know the words to the latest song, but they know the words to the *aarti* (hymn); they may not have computers or fancy history textbooks, but they know the stories of the *Ramayana* and the *Mahabharata* and other holy scriptures; they may not begin their day with newspapers, but they begin with a prayer. They are poor but they carry a glint in their eyes, a glow on their faces and a song in their hearts that no amount of money can buy.

So, what does this mean? It means, acquire possessions if you want to. Earn money if you want to. There is nothing wrong with being prosperous. But remember, what is truly important in life is God. Only He can bring light to our eyes, a glow to our face and a song to our heart.

Giving is Living

There is an old adage that says, 'It is better to give than to receive.' Yet, how many of us actually live by this? How many of us would give to another before taking for ourselves? It is not a simple sacrifice I am talking about. Sacrifice implies some level of suffering. It implies that one is forsaking something one wants out of duty to another. While there is a great deal of spiritual value in the lessons of sacrifice, this is not what I am talking about. For, in true giving, there is no suffering. One does not forsake anything. The giving itself becomes its own reward. People talk about cycles of life. For me, the true cycle is: giving is living, living is learning, learning is knowing, knowing is growing, growing is giving and giving is living. This is the true cycle of life.

Kahlil Gibran has said it beautifully: 'All that we have will some day be given away. Let us open our hearts and give with our hands, so that the joy of giving is ours and not of our inheritors.'

This is truly the message to live by. Embedded within this are many important factors. The first is the fact that we can take nothing with us when we leave this earth. We expend so much time, mental energy and physical energy in acquiring material possessions. Yet, we come into this world with nothing

and we leave with nothing but the *karma* accrued from the life we have lived. Hence, we must re-evaluate the stress we go through to acquire more and more fleeting wealth. That which marks our life, that which lives on after we have departed is that which we give while we lived.

The second important message in the above thought is the idea of the joy of giving. Giving truly is a joy. We think we will be happy if we get this or that. But that happiness is transient. Watch a child with a new toy, for this is a beautiful example of the happiness which is possible through material wealth. The first minute, the child is ecstatic. Nothing else matters in the world; he can barely contain his exuberance. Within a few minutes, we can see the child starting to get a little bored. He looks around; what else does this toy do? Are there any other parts that come with it? Within a matter of hours the toy is lying behind the couch and will only be picked up by the child's mother or father in an attempt to either tidy up the house or restimulate the child's interest.

Yet, then when the child's interest is completely faded, watch the child give this toy to a younger brother or sister. Watch how he loves showing what the toy can do, how he loves telling everyone, "I gave this toy", and how he loves watching his sibling enjoy it.

Isn't this how life is? The pleasure we get out of an old sweater or a dress we wore once or some mechanical appliance that we just had to have, is minimal. Yet, take those clothes or appliances to a homeless shelter; donate them to someone in need. Then we will know real joy; the joy of having given to someone else. It will inspire you to give even more. So

many times we regret having bought something. 'Oh, why did I waste my money?' I have never once heard anyone regret that they gave something to someone in need. I have never heard anyone say, "Oh why didn't I let that child go hungry?" Or, "why did I help that charity?"

Leaving is Losing

Many a time in life, when something does not go our way, we attempt to solve the problem by escaping from the situation. Sometimes this works, but usually it doesn't.

The real lesson in life is to live with it, not to leave it. It is by living with situations that seem difficult that we can attain peace and non-attachment. It is in these circumstances that we learn that happiness can only come from God, not from anything else.

If you are with God, everywhere is heaven, and you would never want to live anywhere in particular. You would see every place as an opportunity to learn, to grow, to serve. However, we say instead, 'Oh this is hell!' and we leave. Yet, if He is with you, how can you be in hell? Hell is due to lack of Him. If the spiritual corner in your heart is not there, you will be cornered everywhere. So, the goal of life is to develop that spiritual corner, to be with Him, and not to escape from a difficult situation.

Be Devoted Inside, Perfect Outside

Our mind should always be with Him, our hands should be doing His work. People think that in order to be spiritual or

to be with God, one must sit in the lotus posture in the Himalayas. This is not the only way. In the *Gita*, Lord Krishna teaches us about *karmayoga*, about serving God by doing our duty. It is the duty of a few saints to live in *samadhi* in the Himalayas. However, this is not what most people's *dharma* is. We must engage ourselves in active, good service, for that alone is the way to be with Him.

One of our prayers says, "*Mukha mein ho Rama-nama, Rama-seva hatha mein.*" This means, 'Keep the name of the Lord on your lips and keep the service of the Lord in your hands.' Let the inner world be filled with devotion to Him and let our outer performance be filled with perfect work, perfect service.

I once heard a story about a man who spent 40 years meditating so he could walk on water. He thought if he could walk on water, then he would have attained spiritual perfection, that he would then be 'one' with God. When I heard this story, I thought, why not spend Rs 40 instead, sit in a boat to cross the water and spend the 40 years giving something to the world? That is the real purpose of life.

However, there must be both devotion and service. We cannot develop one at the expense of the other. We can't be truly perfect on the outside unless we are devoted on the inside, for only then will God's work shine through us. Similarly, we cannot say we are truly devoted on the inside unless we are doing perfect work on the outside.

Faith Counters Fear

In a question-answer session, a woman asked me with tears in her eyes, "How do you overcome fear? I live my life in fear all the time. The object of my fear changes as time passes, but the fear remains."

In my opinion, this omnipresent fear is the most insidious obstacle to peace, happiness and progress in life.

When I say fear, I don't necessarily mean terror. Rather, I mean all that makes us anxious, nervous, tense and in need of controlling our surroundings. The root cause of fear is distrust. We have been betrayed, injured and abused. We decide that the world cannot be trusted. This way we lose that faith which is so crucial.

What is the answer? The answer to fear is to firmly root ourselves in God (by whatever name, whatever form we choose). When we realise that God is always with us, always for us, we will never be afraid, regardless of the circumstances.

Sure, our family and friends may betray us. They may injure us. But, if we give ourselves to God, if we make our

relationship with Him our first priority, then we will never be broken inside; we will always be cared for.

There is this story of a powerful king. This king prided himself on being generous and caring for all his subjects. He would often boast that no one in his kingdom was hungry or cold or impoverished. Once, a holy man came to see the king. The king told the holy man how he had provided for everyone in the kingdom. The holy man asked the king to come for a walk. While they walked in the forest, the king picked up a large rock by the side of a stream. "Break the rock," the holy man ordered the king. The king looked surprised but immediately told his servant to smash the rock. As the rock broke open, they saw a small frog, living peacefully in the nutrient-rich water which had gathered inside the rock.

"Have you provided for this animal as well?" the holy man asked the king.

The king realised that he could not possibly provide something as perfect, as intricate as this shelter for the frog. He decided that it really is God who provides for all His subjects.

We must realise that if God can provide for even the smallest insects, He certainly will provide for us.

A young boy was travelling on a ship. The ship got trapped in a large storm and the waves started rocking the boat furiously. The passengers screamed and cried and held on to each other for dear life. In the midst of this terror sat a very young boy, calm, composed and angelic. When asked why he did not cry, he answered, "My mother is here, so I know everything will be all right." We must also cultivate such faith. If God is here, if

God is with us all the time, then everything will be alright.

We take out insurance policies to protect our home, our property, our car. But, what about our lives? Who will protect our lives? We must remember our divine insurer, our God. We must place all our faith in Him. He will never betray us, and we can be assured that we are in the best of hands.

Once, many years ago, when I first went to the USA, I was on an airplane, flying to Chicago. It was wintertime and the plane came under turbulence and stormy weather. The captain's panicked voice over the loudspeaker instructed everyone to assume the crash position. The passengers screamed; some even fainted. Cries of "We're going to die!" could be heard coming from all directions. I was sitting next to a very respected professor. As everything descended into chaos, I continued calmly writing on my notepad. "What are you doing?" the professor asked. "How can you work? The plane is going to crash. What are you possibly working on?"

I told him, "Professor, I am working on my speech. See, I know that I will be all right. I have perfect faith in God. But, as everyone else seems convinced they will die, it means I will be the only survivor. Therefore, I will have to give a speech on what it was like to survive this crash. And as I will have to give the speech in English, I thought at least, before you die, I could ask you any question I might have regarding the English vocabulary."

We must realise that we are God's children. Just as a child is never afraid when his mother is near, so we must never fear. Fear immobilises us. It freezes us, preventing us from thinking clearly. And most of all, it serves no purpose.

No tragedy has ever been prevented by fear. No catastrophe has ever been averted by anxiety. A calm, serene, wise understanding of the situation, coupled with undying faith, is what is needed.

There is this story of Swami Vivekananda, whose message to the world was, "Stand up, be fearless, God is with you." To test his faith, some people staged a scene during one of Swamiji's lectures. In the middle of the lecture, gunshots rang out and bullets whizzed past Swamiji's head. The audience screamed and ran for cover. Some dropped to the floor to protect themselves. Only Swamiji remained perfectly calm and composed. Later, he explained: "The bullet which is not meant to take my life will never hit me, even if fired from point-blank range. The bullet which is meant to take my life will kill me, even if I am protected by a hundred guards."

So, let us renew our faith in the Supreme. Let us do away with our fears, our anxieties. Let us realise that everything is just as it is supposed to be. We are in the lap of our mother. How can anything go wrong?

Rebirth for Attaining Salvation: Questions and Answers

Rebirth is the philosophy of the Hindu religion. Does any other religion advocate the same philosophy?

Sikhism, Jainism and Buddhism subscribe to the philosophy of rebirth and reincarnation.

What is the meaning of rebirth? What relevance does it have to the common man?

Rebirth refers to the soul casting off the body in which it lived and inhabiting a new body — one which will be conducive to its evolution.

The undeniable implication is that our lives are not merely limited to the 50 or 60 or even 80 years that we spend in this current body, but rather that we live again and again. Intricately connected to the philosophy of rebirth is the philosophy of *karma*, for it is our *karma* which determines the body that our soul will inhabit next. Our *karma* determines both the positive and the negative situations in which our soul will find itself in the future. Thus, if we cause pain to

others in this life, it is likely that we ourselves will experience pain, both in this birth and in the future.

The belief in rebirth serves several purposes. Firstly, it ensures that we live our lives honestly, compassionately and purely. If we fully understand that our present actions determine our future circumstances, then we will act with discretion, love, peace and generosity. Just as people do not accelerate their car when there is a policeman present for fear of receiving a ticket, similarly, we will lead a disciplined life when we realise that our every action is being recorded.

Belief in this philosophy also provides hope to people. We see that this life is not our only chance. If someone has lived a life of greed, lust, anger or *adharma* and if he does not adhere to the philosophy of rebirth, then he would feel hopeless and fated to a life in hell. On the other hand, rebirth offers him another chance. *The laws of rebirth and* karma *say that your future begins right now. Change yourself today so that your future may be bright.*

What is the reason and purpose behind rebirth?

There are several purposes of rebirth. The first purpose lies in the realisation that as humans we are weak. We succumb to temptation, to desire and to our emotions. Rebirth offers us a vision of life as a continuation from low to high, from impure to pure, and from human to divine. It allows us to accept our weaknesses without feeling damned to a life in hell, while simultaneously striving to live our lives in a way that will ensure a positive tomorrow.

Secondly, the purpose of rebirth is to show people the inevitable consequences of their actions. If we play hide and

seek with a small child, she will frequently hide right in the middle of the room, closing her eyes in the belief that since she cannot see you, you too will not be able to see her. People too, assume that just because they don't believe in the law of *karma*, it will not affect them. Yet, though our eyes may be closed, God can see us and His law of *karma* catches up with us regardless of where we are.

There is no way we can escape the eyes of *karma* or the law of rebirth. Thus, through these laws, God has given us both an ongoing chance of self-improvement and an inescapable equation by way of which we always reap what we sow.

Thirdly, another important purpose of rebirth is to fulfil unfulfilled desires. As long as we have a desire for anything other than God, we cannot attain liberation. In fact, liberation is freedom from all desires. Thus, until our mind becomes desireless, we will continue to engage ourselves in actions to fulfil these desires. These actions are what lead to *karma* — both good and bad — binding us in the chains of birth and death. Thus, through rebirth we continue to live until we realise that God is the only thing worth desiring. Then, falling in surrender at His holy feet, we begin treading the path towards a desire-free and liberated existence.

Thus, the most important purpose and reason for rebirth is to attain liberation, to become one with God. People can go astray in one life. People can choose paths of passion instead of piety, paths of decadence instead of discretion and paths of hedonism instead of honour. Yet, God wants us all to come to Him. That is the purpose of human birth. So, He gives us

more chances. We keep coming back until we learn the lessons of this human birth and until we transcend the limitations and temptations of the flesh. Thus, we must realise that everything we do which is not conducive to the path of God is simply an obstacle we are putting in our own way. Every act we commit which is not honest, divine and pure is simply a stumbling block we place in our own path. It is simply one more hurdle we will have to cross, if not in this life, then in our next one.

We know about the ten incarnations of Lord Vishnu. Does God descend on earth by taking the form of man or through some other way?

God is God, so He can manifest in any way. He can manifest in human form or in a non-human form. He is not restricted in any way. Rules applicable to man do not apply to God. All His manifestations are divine.

How many times can a soul be born? Can a soul say, "It is enough; now I do not want to be reborn?"

A soul will come to the earth in human form as many times as is necessary to attain the final state of liberation. The faster one progresses, the fewer the births that are necessary. Yes, a soul can certainly decide that this is enough and that it does not want to be reborn. However, simply wanting liberation is not enough. One must work for it. This is the point of *sadhana*, of *sewa*, of *japa*, of meditation, of yoga. By these means, the soul sheds layer after layer of illusion, ignorance, attachment and desire. Once the layers have all been shed, once the soul realises its true, divine nature, then rebirth is not necessary. Through this discipline one can break the cycle of birth and death.

Attaining liberation is not merely due to a 'request'. God shows us the light by which we can see the path to reach Him. He gives us the light of discretion, the light of wisdom and the light of truth by which we can find our way.

Thus, we cannot simply say, "I want liberation," and then continue to accumulate *karma* that will bind us. All actions, whether they are good or bad, result in *karma*. In order to completely break the chain of *karma*, we must lay our entire lives — every thought, every action, every word and every desire — at His holy feet, realising that He is the doer and we are merely the vessels through which He does.

In the *Bhagwad Gita*, Lord Krishna says:

Yat karosi yad asnasi, yaj juhosi dadasi yat

yat tapasyasi kaunteya, tat kurusva mad-arpanam.

Subhasubha-phalair evam moksyase karmabandhanaih

sannyasa-yoga-yuktatma vimukto mam upaisyasi.

'Whatever you do, whatever you eat, whatever you give and whatever *sadhana* and *tapasya* you perform, do everything as an offering to me. In this way you will be freed from the bondage of *karma* and from the results of *karma* in your life. Through this renunciation of everything unto me, you will be free of all bondage and you will become united with me.'

When we perform a *yagna* we say, "*Idam agnaye, swaha, idam agnaye, idam namamah.*" 'Not for me, but for you, God.'

This must be our attitude not only in *havan* ceremonies, but also in every action of our life. Everything must be done as an offering to God.

Furthermore, it is only through becoming desireless that

we can stop accumulating *karma* and attain salvation. In order to become desire-free, we must perform *sadhana* to realise God. A child will be very attached to his toys and will desire more toys. However, by the time he is an adult, he will no longer be interested in these toys. Similarly, we must also reach a state where God becomes the prime and the rest remains secondary.

The next birth for a saint like you will be progressive and important like this birth. Do you know what will be your next birth?

For me personally, I am not concerned about where I am born. I want only to continue to serve God through service to His children. The point of rebirth is not to be concerned with when, where and how, but rather to make here and now your heaven! Liberation can take place now, if only we will work for it.

With the blessings and the grace of God, every moment of every day can be a liberation. In a rat race, you are always a rat. Even if you win the race, you will still be a rat. The point of life is to live with grace, not in a race. Yes, we must perform our duties to succeed in whatever way we can. But, we must live in grace, not in a rat race! That is the point of a divine life.

We should take the divine life of *Bhakta* Prahlad as an example. Lord Vishnu offered him anything he wanted on getting pleased with his devotion. What did he ask for? He said, "Regardless of where I take birth, regardless of what form I come in — be it a scorpion, an insect, a tree, an animal or a man — the form and the place and the

circumstances are irrelevant to me. I only ask that in whatever form I take future births, please bestow upon me the blessing of undying devotion to Your holy feet." The only thing he wanted was to live his life with the divine nectar of *bhakti* filling every pore of his body. He wanted to be completely saturated with love for God.

If someone leads a virtuous life and achieves nirvana, does that mean there is no rebirth for him?

Yes, if one achieves *nirvana*, then that is the goal of human birth and one gets liberated from the cycle of birth and death. However, saints may choose to return to earth, although they don't have to, in order to ease the pain of those who are living on it. Yet, the difference between the liberated ones and those who are still bound by the laws of *karma* is like the difference between the prisoner and the jailer. Both live within the confines of the jail. However, whereas the prisoner lives according to the rules of the jail and his every movement is restricted, the jailer is free to move about as he wishes. He is not subject to rules and no one monitors his movements. Furthermore, while the prisoner must stay in jail until his term expires, the warden is free to leave, either temporarily or for good.

Similarly, an enlightened soul is on earth by choice, in order to help others attain liberation. He is free, not bound.

Can a person really have knowledge of his previous birth? If so, is this knowledge beneficial or to his disadvantage?

Usually people cannot remember previous births. One must perform great *sadhana* or go to saints or special *jyotishis* (astrologers) to learn about previous births. It is usually not

advantageous to know, which is why the divine plan does not give us easy access to that information. We have enough trouble trying to navigate through one life, with one husband or wife, mother, father, job, etc. Imagine if we were to recognise others as our previous parents or spouses or vicious enemies, it would be impossible to remain neutral and unbiased.

Suppose a man is married to a woman with whom he is not deeply in love. However, out of duty, he stays married and lives an upright life. Now, imagine that one day he sees a very old woman in the grocery store and immediately recognises her as his beloved from an earlier birth. He would encounter difficulty in not leaving his wife and family for an old woman whom he longed for passionately in an earlier life!

Or, imagine a young man and woman fall in love. The man goes to the woman's parents to request her hand in marriage, and the girl's father immediately recognises the boy as an enemy from an earlier life. He would never allow his daughter to marry the man, although perhaps through the last few lives the man might have transformed from a rascal to a righteous human being.

There as some people who talk about remembering one's previous life, but how many lives do we want to remember? One, three, 10, 50? Where do we stop? Eventually, we would be living in a situation where all the people we meet have played some role in an earlier birth, thus preventing us from treating them fairly and dispassionately in this birth.

Why should the soul take birth on earth only? After leaving the human body, can a soul be born in any other form?

When we realise the purpose of rebirth, then it becomes

clear as to why the earth is the best place and why the human body is the best medium. The purpose, as we have discussed, is to work through previous *karmas*, to become desireless (through either fulfilment of the desires or through *sadhana* to eradicate the desires), and to attain God. The human body, with its intellect, compassion, consciousness, yearning, understanding and wisdom, is most conducive to attaining God. As an animal, our lives would be spent solely in eating, sleeping, protecting ourselves and reproducing. There is no ability for *sadhana*. Similarly, plants and other species have the consciousness to feel pain and to reproduce, but their brain is not developed enough to search for something higher.

However, occasionally, due to the performance of truly evil deeds and accumulation of significant negative *karma*, a soul will have to come to earth in the form of an insect or a lower life form. As soon as the lessons are learned in that life form, then again the soul can descend in the form of a human, in order to continue its progression towards realising God.

How many times does a soul take birth? Does the soul remain the same through each birth? When it is born, does it look the same each time?

First of all, the soul never actually takes birth. Rather, the soul inhabits human bodies in order to come to earth, the *karmabhoomi* (land of *karma*), so that it can engage itself in actions which will lead to its liberation. The individual soul comes to the earth in situations which will be conducive to working through the past *karmas*, enabling the mind to become pure and desireless, and helping it attain salvation.

People frequently think it is the soul that must work

through the *karma* or that has desires. No, the soul is pure, divine and complete. Rather, it is the mind, the senses, the *pranas*, desires, *sanskaras* and tendencies which form the subtle body and travel with the soul from one gross body to the next to obscure the true, divine perfection of the soul.

The soul it is like a perfect reflection of the sun (a reflection of the supreme reality) which becomes distorted and murky due to the dirt and waves in the water in which it is being reflected (the mind and the senses). The reflection (the soul) is perfect. It is only the vehicles of reflection (the mind and senses) which are turbulent and murky, thus making the reflection unclear. Once the water becomes clear and calm, the sun will reflect perfectly. Similarly, once the mind and the senses become calm and clear, through *sadhana*, through good work, the individual soul can manifest perfectly and attain liberation.

If we have good parents, brothers, sisters, friends and gurus, how can we have the same relatives and friends in the next life? Does a soul have the right to select its family and friends?

There are two important points. Yes, on the one hand, we can hope to be with certain people again in our next life. The only way to do this is through prayer. It is not a matter of the soul having the 'right' to choose. Rather, if someone prays with great sincerity, purity and devotion, then God may answer his prayer.

However, the other important thing is that the purpose of life is not to become so attached to our family and friends that we worry about not being with them in our next birth. We have a hard enough time living together in this life! So

many times we cannot even get along with our family members in this life; we must focus on loving and caring for each other *now*, rather than be concerned about whether we will be together in the future or not.

Also, when a soul departs from the body, the soul continues its journey towards realising God. Scriptures caution us against thwarting the progress of other souls. By begging to stay together with someone, we may be inhibiting his or her progress on that path.

Thus, let us instead concentrate on loving those we are with now. Let us care for all those who come along our path. Let us pray to move forward with each birth and let us not be so attached that we sacrifice our own or someone else's spiritual growth in order to simply stay together.

Does the karma *of this life become useful in the next life? If the present life is happy, does that mean the soul has done good deeds and is suffering for the misdeeds of its last birth? Can you please explain the law of* karma?

Yes, the *karma* we perform is extremely relevant to our next life. However, good deeds in one life do not necessarily beget happiness in the next life, or bad deeds beget unhappiness. First of all, *karma* can fructify immediately; it does not necessarily wait until the next birth. We always reap what we sow. Therefore, performing good deeds with a selfless motive will definitely lead to positive *karma*, both in this life and in future lives.

However, there are a few important points. First of all, motivation is essential. We must perform our duties with no motivation other than to do God's will purely and selflessly. If

we do good deeds so that we will reap good *karma* (e.g. going to the temple in order to pass an exam, or being respectful to our mother so that she will raise our allowance), then we cannot derive the long-term benefits. Rather, we must do good deeds because it is the right thing to do. We must perform the right action because that is what will lead us to God. We must not concern ourselves with the immediate fruits or results.

Secondly, it is important to realise that what may seem negative need not necessarily be so. For example, if an innocent boy dies at the age of ten, people immediately question, "What horrible sin did he commit in his past birth to suffer such tragedy in this one?" Perhaps death was due to his negative *karma*. But maybe he had come close to liberation in a past birth and only had a few *karmas* to attend to before his soul was ready for salvation. So, rather than being a tragedy, early death could be a blessing.

Can a great soul take rebirth to finish its work? Are there any such examples? Or if two lovers fail to live together in this life and if they commit suicide, will they get together in their next life?

Yes, souls can come back to finish their work. There are examples in history of proven cases of reincarnation. In fact, when I was young and doing *sadhana* in the Himalayan jungles, I met several people (including small children) who told me about their past births, right down to the smallest detail of their homes and their previous families. They explained the circumstances of their death and how their work was thwarted by death. These details of their lives have been confirmed through independent sources.

However, to commit suicide in the hope that in the next life our wishes will be fulfilled is a grave mistake; suicide is never the answer to achieving *moksha* or reincarnation.

God has given us a great gift in the form of life. Through this life we get the opportunity to move closer to Him, but if we throw away this chance, then we are the losers. People, especially youth, make the tragic mistake of thinking that suicide can provide a fresh start in a new life. But, the exact opposite may happen. By committing suicide they condemn themselves to a lifetime of not only the exact problems they faced in this life, but also to the negative *karma* accrued by killing themselves. Thus, their next life will inevitably be much more problematic and painful than the current one.

Some people donate arms, eyes and kidneys after death. Do these good deeds at the end of life help the soul to take rebirth? Is it beneficial to the soul or does the soul suffer for the mutilated body?

Whatever we do, in life or in death, that helps others is a good deed. We should help others as much as we can during our life and if in death, we can help them further, then we should not think twice. There is the tradition where saints are not cremated; rather, their bodies are set afloat down the River Ganga. This is to allow fish and other animals to feed off them and acquire nourishment from their bodies. Saints devote their life to the welfare of humanity and even in death they want every cell of their body to be useful to another creature.

So, the soul certainly does not suffer by donating organs; in fact, it benefits. Our soul benefits through every good deed we perform, be it in life or in death.

Fast to Connect with the Divine

A fast is	A fast is not
about God;	about food;
a time of reflection	a time of hunger,
for peace of the body,	for *pakoras* and
mind and spirit;	*puris;*
a day of discipline	a diet
to purify you.	to frustrate you.

Fasting has now become a fad across the world. Volumes of literature extolling fasting can be found in any bookstore. There are juice fasts, water fasts, fruit fasts, etc. Fasting is frequently heralded as the 'miracle weight-loss method' advised to those who have tried all else without success.

However, while fasting is certainly of great benefit to our health, to define it merely as a type of 'diet' is to undermine this oldest and most sacred spiritual practice. Fasting has been used for millennia by *rishis*, saints and sages to purify their bodies, minds and souls and to bring every cell of their bodies in tune with the Divine.

A True Fast

A true fast, undertaken with understanding and discipline, has the ability to restore all the systems of the body. The nervous, circulatory, digestive, respiratory and reproductive systems get regenerated. Toxins and impurities in the blood and tissues get eliminated and the system is rejuvenated. A majority of today's terminal illnesses are rooted in over-consumption, and a fast is a way of purifying our body of an excess of not only food but also of preservatives, chemicals and toxins.

A fast is also one of the best ways to control our mind and senses. A fast has been used for millennia to subdue passion, anger and lust. It helps to withdraw the senses from the outside world and to become refocussed on our own divine nature and proximity to God. Additionally, during this period of *sadhana*, austerity and restraint, one is able to master one's body; not vice versa.

Unfortunately, today most of us have forgotten the purpose of a fast. We see people with plates overflowing with *puris* and *pakoras* say that they are fasting. There are *phalahari chapatis*, *saboodana khichari* and other hearty meals for fasts. I have heard that there is even a recipe for *phalahari* pizza dough!

On the one hand, it is nice to see such a proliferation of *phalahars*, and I am glad to see that observing weekly fasts or fasts on *Ekadashis* are rituals which have not been lost as we enter the 21st century.

However, it is crucial to pause and reflect on what a fast is, for even though the idea of a fast is still upheld with great fervour, its true meaning and purpose can be obscured by the latest *phalahar* recipes.

In Sanskrit, the word for fast is *upvas*. This literally means 'sitting near...' Sitting near whom? Near God. Fasting is a time in which our bodies become light, our vital energy is not dissipated through the process of consumption and digestion, and we feel free from the heaviness and lethargy that result from over-indulgence.

However, a fast is not meant to merely refrain us from eating. In fact, it is not necessary to entirely give up food on the day of a fast. Fruits and milk enable our body to remain strong and active while simultaneously giving us the benefit of a 'fast'. *Upvas*, however, is not as simple as just reducing one's caloric intake or avoiding certain foods. *Upvas* is not a time in which only our stomach is free from excessive external stimulation. It is not a time for mere restraint of the tongue, rather, it should be a time in which all of our organs are restrained, and purified and our attention is focused on the Divine.

Our tongues should refrain from indulgence in food and drink, as well as from indulgence in speech. A fast should also be a time during which we observe silence as far as possible, for we lose much of our vital energy in speech, and through speech our focus becomes diverted outwards.

Fast for All Senses

We think that we 'eat' only through our mouths, that our meals are the only 'food' our body gets. However, what we hear, what we see, what we touch — all these are ingested into our body as food. Just as pure, wholesome food imparts health to the body, so do pure, wholesome sights, sounds and

other stimuli provide health to the mind, heart, and soul. Therefore, when we undertake a fast, we must stress on purifying the food that we take in through our eyes, ears, and hands as also through our mouths.

During our fast, our ears should refrain from hearing anything other than the chanting of the Lord's name, as it is beneficial for stabilising our thoughts. During a fast we should not listen to rock music, watch TV, or be part of idle gossip. It is often seen that in temples, people who have spent the whole day fasting, tend to huddle together to gossip and chat. Their bodies may have gone without food, but their soul has not fasted.

Additionally, that which we see — frequently without even noticing it — penetrates our minds and hearts and changes our perspective. The simple sight of a woman's bare leg may arouse lust in an otherwise simple and pious man; the sight of blood may cause nausea and panic in one who is usually calm; the sight of an enemy may immediately evoke animosity in one who is usually peaceful and loving.

When we fast we must limit all stimuli which we perceive. That is why we should 'sit near God'. Sit in the temple in your home or outside or be with Nature. Just ensure that the sights and sounds we imbibe during our fast are pure, pious, loving and filled with divinity. Even if we go to work or school during a fast, we must avoid situations in which we see or hear things that incite, disturb or distract. It is better to take a longer route if it takes us down a tree-lined road rather than a packed freeway. Spend lunch-break walking in a park or meditating with eyes closed rather than sitting in a cafe conversing with

friends. Remember, a fast is not meant to be like every other day.

It should be a special day of purification devoted to remembering God. Remember, it is a day for 'fasting' for all of our senses. During a fast we should also try to quieten our mind as much as possible, as unnecessary energy is drained in a ceaseless, incessant thought process. And frequently it leads only to more confusion and more questions. Therefore, just as we give our bodies a rest from digesting food, we should give our ears a rest from digesting impure thoughts, give our eyes a rest from over-stimulating or sensual sights, give our minds a rest from harbouring all kinds of thoughts.

Many people fast on a particular day of the week. The days in an Indian week are marked in honour of a particular deity or aspect of the Divine. Monday is the day dedicated to Lord Shiva; Tuesday to Hanuman, Thursday to the guru. It is said that on these particular days, the Divine is closest to the devotee. So, devotees observe a fast on a particular day to offer their respects to the Lord and to seek His blessings.

However, at times fasts are a mere ritual, the spiritual aspect getting lost in many cases. People observe fasts because they've done it for years or because their parents did it. Rarely does a devotee truly remember the Divine for whom he is on a fast. Again, we frequently see plates of *puris*, *pakoras* and *laddoos* in front of the devotee with the day spent just like any other day.

Indian culture and Hindu tradition are meant to bring us into close contact with the Divine. Rituals were given to help us step out of the mundane world and re-establish our divine connection. If we fill our stomachs with *pakoras* and *laddoos*

and fried potatoes, are we really likely to remember God? Neither does this mean that one must subsist on an empty, aching stomach. One can take fruit, nuts and milk without losing the effects of the fast. But, these fruits should be pure and simple. It is better to eat an apple or some almonds than *pakoras* and *chapatis* made from *phalahari* flour and filled with fried potatoes!

The point of the fast is to feel light while meditating. The mind should be away from food, away from the mundane world and focused on the Divine. The energy which a body saves on fasting is diverted towards physical repair of the body as also to the vital spiritual *shakti*. The point of being a little hungry is to remind ourselves of why we are fasting.

I heard a beautiful story of a great saint who could cure lepers of their oozing wounds. One day, a very sick man came to a female saint, who carefully placed her hands over his gaping wounds. Instantaneously, the wounds were healed beneath the touch of her divine hands. However, when she sent him away, she left one wound untreated. Her devotees questioned her for doing so. Her answer was, "Because it is that one bleeding wound which will keep him calling out to God."

Our lives are extremely busy and filled with so many small errands, appointments and pleasures that we rarely find time to remember God. We tell our loved ones that we miss them but do we tell God that we miss Him? Those who do so are very rare and very divine. We normally tend to remember God in times of adversity. Our child is in the ICU after a car accident and so we begin to religiously chant *mantras*. We find a lump in our wife's breast and we start visiting the temple religiously.

We want promotion at work and so we perform a *yagna*. This is not wrong; this is human nature. Most of the time we are busy but find ourselves turning to God in times of need.

Even if we cannot take the day off from work to sit in *puja* or meditation, the constant feeling of mild hunger in our bodies keeps us connected to the reason for the fast, and thus we are reminded of God throughout the day. That doesn't mean we must starve ourselves completely. Those who are working or going to school or whose health does not permit them to fast should not worry; they can take fruits, nuts and milk, but as little as is necessary for them to attend to their daily tasks. Try to leave enough empty room in the stomach to be reminded that you are on a fast. Try to eat only those things which are easily digestible and preserve the vital energy of the body.

If we satiate our hunger with platefuls of *phalahar*, then in many ways we defeat the purpose of the fast.

Some people fast twice a month on *Ekadashi* day. The 11th day of each lunar cycle is observed as a special *Ekadashi* fast. The importance of observing *Ekadashi* is written in both the *Puranas* as well as in the *Upanishads*. It is said that by observing one *Ekadashi* fast with reverence, one attains the benefits of performing a wide range of extended austerities. However, *Ekadashi* is of an importance far greater than simply the abstinence from rice and grains. It symbolises control of the mind.

The *Upanishads* say that to control the mind is the greatest accomplishment. They say that when the mind is under control, all else — the senses, the body — will follow. "The body is

 46 Drops of Nectar

the chariot, the senses are the horses pulling the chariot and the mind is the driver with the reins in its hands." So, if the driver is calm, pious and peaceful, he will drive the horses and thereby the chariot towards peace, love and God. But, if the driver is tempestuous and intractable, then the horses jump and buck wildly, leading the chariot to dash here and there, eventually collapsing upon itself.

Our scriptures say we have ten sense organs, and the mind is the eleventh. *Ekadashi* stands for the eleventh, and since the moon is symbolic of the mind, the eleventh day of the lunar cycle is thus conducive to practices which teach us control of the mind.

Ekadashi is, therefore, a fast for the control of the mind. It is said that if a seeker observes even one *Ekadashi* with true commitment, faith and devotion and keeps his mind entirely focused on God during the course of the *Ekadashi*, then this seeker is freed of all *karmic* cycles of birth and death.

The *Puranas* encourage complete fasting on *Ekadashi*, but some take roots, fruits, milk and water. This is important, because the scriptures specifically state that this is only for those who are weak. Today, however, we can also interpret this to include all those who would become weak (and therefore unable to perform their tasks) if they abstain completely from all food. There are many students and others whose jobs or studies are so taxing and straining that the body requires some caloric intake. For these people, it is fine to take fruit, juices and milk. As far as possible, though, people should refrain from eating at all on the *Ekadashi* fast, unless it is necessary. If necessary, fruits and milk should be taken

in their purest, simplest and most unadulterated forms. Unfortunately, today we see *Ekadashi* feasts, where healthy, strong people load themselves with sumptuous meals prepared without any grains or legumes. This completely defeats the purpose of the fast.

Further, it is said that the day of *Ekadashi* is meant to be spent chanting the holy name of Vishnu and performing Vishnu *puja*. If we are able to take the day off from work and do this, it is wonderful. If not, we should be sure that at least some time is spent, in the morning before leaving home, in meditation on the holy form of Vishnu and in chanting His name. If we must be at school or work during the day, let us vow that at least every two or three hours we will take a five-minute break and sit silently, chanting God's name. Let us also vow that when we return home at the end of the day, we will spend one special and extra time in meditation and in prayer. A fasting day should make us feel more divine and more holy than other days, but it is up to us to make the choices and decisions that will lead to that special divine feeling.

If we want to truly reap the benefits — spiritual and physical — of *Ekadashi* and of other fasts, we must follow the strict principles laid out by the sages and saints in the scriptures. These principles urge us to refrain from filling any of our senses (our mouths, eyes or ears) with that which is unholy, and urge us to spend our 'fast' engaged in contemplation of the Divine.

Let us all vow to observe fasts — what exactly we eat or don't eat is not as important as the spirit in which the fast is done. What is important is to spend the day of the fast meditating upon God. Be light, be restrained, and be disciplined. Be focused.

A Prayer

Mein to kab se teri sharan mein hun.
Oh Lord, I have been waiting for you,
life after life, birth after birth.
When will you come and take care of me?

Meri or tu bhi to dhyaan de.
Please, Oh Lord, I am at your holy feet, yearning for you.
Please pay just a little attention to me.

Mere man mein jo andhakaar hai.
Oh Lord, my heart and mind are flooded with a darkness
known only to you. You know how weak I am. You know
how plagued I am by the darkness.

Mere ishwar mujhe gyaan de.
Please Oh Lord, ocean of mercy, ocean of compassion,
shine upon me the light which will remove this darkness.
Bestow upon me the light of understanding and wisdom so
I may remain true to you, in spite of the trials and
tribulations of life.

Chahe dukh ki rehn mile to kya,
chahe sukh ki bhor khile to kya.

Let me be filled with divine bliss and acceptance in every circumstance, whether it's the dark night of sorrow or the dawn of joy.

Patajhar me bhi jo khila rahe
main vo phool ban ke rahun sada.

Make me the flower which always blossoms, whether it's spring, summer, winter or fall. Even in autumn, when all others are dropping, let me continue to blossom.

Jo lute na fiki pade kabhi,
mujhe vo madhur muskaan de.

Give me the sweet, loving smile which never fades, even during times of adversity.

Teri aarati ka banoon dia,
meri hai yahi mano kaamana.

Oh Lord, I have only one desire: make me the lamp of your *aarti*. Let me be the flame which burns with devotion for you, and which is so bright it throws your divine light on others.

Mere praana tera hi naam lein, kare man teri hi aaraadhana.
Gunagaan tera hi main karoon, mujhe vo lagan Bhagawan de.

Let my every breath chant your name. Let my heart beat only for you. Let my every action be in your service. Let not only my lips sing your glories, but let my heart also sing your glories.

Mujh mein hai raag aur dwesh bhi,
ninda paraayee mein karoon.
Oh Lord, I am afflicted by attachments and jealousy.
I am burdened by the habit of condemning others.

Andhkaar ko prabhu har lo tum.
Oh Lord, please remove me from this darkness. Annihilate
my ego, my arrogance, my anger, my attachments.

Mujhe divyata ka daan do.
Please bestow upon me the gift of divinity. Make me pure.
Make me divine. Oh Lord, bless me, bless me.

Tera roop sab me niharoon mein,
tera darsh sab me kiya karoon,
mujhe vo nazar Bhagwan de.
Give me that divine sight whereby I see only you,
only your beautiful image in all I behold.

Prayer as Bridge Between World and Divine Realm: Questions and Answers

Prayer is calling back home.

Prayer is, in essence, coming home,

for it connects us with our deeper selves.

It is the way we speak with God,

and its beauty and poetry and devotion should match

that in our hearts.

Prayer is the broom that sweeps our hearts,

so the home we offer to God is an immaculate

and pure one.

Prayer is a time when our mouths,

our minds and our hearts are filled with the glory of God,

when we simultaneously speak,

think and feel our love for Him.

Prayer is the blanket that wraps itself around our souls
and keeps us warm and cosy.

Prayer is the water that quenches the thirst
of a man lost in the desert.

It is the stars that glisten in the dark of the night,
giving light to all those who may need it.

It is the sun that shines in the middle of winter,
coaxing the flowers to open their petals.

It is medicine to the sick, food to the hungry
and shelter to the homeless.

When and why should one offer a prayer? Is there a
specific time of day for it?

Prayer should be done anytime and all the time; anywhere
and everywhere; for any reason and for all reasons. When we
speak to God, that is called prayer. Therefore, prayer should
be a minute to minute, moment to moment, integral part of
our lives. Prayer makes us God-conscious; it brings us into
divine connection. It takes our focus away from the material
world and into the spiritual world.

There are, of course, days which are considered auspicious
for offering prayers. Additionally, there are three times each
day when it is particularly important to pray. The first is when
we get up in the morning. We dedicate our day to God,
'God, this day is yours. Guide my actions, speak through my
voice, make my hands your tools.' Then, at the end of the

day, we offer the day to God, whatever we have done, good or bad, we lay at His holy feet. Our successes are due only to His grace, and He alone can take care of our weaknesses. Also, before each meal, we offer the food to Him, so that it becomes *prasad*, nourishing our being with nutrients and His divine light.

However, although certain times and certain days are especially important, the goal is to make every day a holy day; start every day with a prayer. Fill every day with a prayer. End every day with a prayer.

Should prayer include mantra, japa, puja, archana, yagna or havan? If so, why?

Mantras and *japa* help us concentrate. We live in a world that is overflowing with sensory pleasures and stimulation. Our lives are excessively busy with work, errands, chores, etc. Therefore, it is very difficult to still the mind. *Mantras, japa* and special *pujas* serve as a bridge between this world and the divine realm.

It is said that a *mantra* has three essential components: we must simultaneously picture the *mantra*, hear the *mantra* and taste the *mantra*. It is an experience that fills our entire being.

Mantras and *japa* also purify our minds and hearts. Our unconscious thoughts are normally filled with trivial matters — conversations we have had or expect to have, groceries we must buy, what we will cook for dinner, or even a persistent commercial jingle. However, by practicing *mantras* and *japa*, such disturbing thoughts get pushed aside automatically with the chanting of God's name. Soon, the *mantras* and *japa*

become as automatic as our other thoughts. It is like if you hear a song on the radio over and over, during your drive to work, that song will play in your head all day long. Similarly, if you recite a *mantra* or *japa*, it will eventually happen automatically. Your mind will no longer be filled with trivial thoughts and worries. Every free moment will be filled with God.

Also, just like a mother cannot ignore her child who cries out, "Mom, Mom, Mom, Mom," so will God be always present with His devotees who chant His holy name.

However, these things are a means to the end of realising God. They are not the end in themselves. Once we develop that close, intimate bond with God, *mantras* and *japa* become less necessary. Imagine that you love someone with all your heart. You don't need to take a *mala* and recite her name over and over again in order to remember her. Your heart automatically remembers. Similarly, once we develop that deep love for God, we don't need to continue doing *japa* to bring us into contact with Him. We will be in contact all the time. Our lives will become our *japa*.

Should one chant slokas during prayer? Does the mantra given by a guru have any significance? If so, why?

There are hundreds of different *slokas* and prayers; it is impossible for me to say which should be recited. This is the reason we have gurus. After much thought and meditation, the guru will tell the disciple which *mantra* to recite. If you do not have a *sadguru*, you can take any name of God, whatever form attracts you most. All of His names are holy; all of the *mantras* praising Him bring you to His feet.

Yes, a *mantra* given by a *sadguru* has a special power, a special significance. A guru passes on not only the words of a *mantra*, but the tradition and the *sadhana* of so many enlightened beings. He gives not only his wisdom and *tapasya* but also the wisdom and *tapasya* of his own *sadguru* and his guru's guru. So, a *mantra* from a guru carries with it the guru's light, the guru's understanding and the guru's love.

However, I always say that what matters is your faith, your *shraddha*. That is your real *mantra*. The words themselves are not as significant as the heart that recites them. So, when we recite complex Sanskrit *slokas*, let us ensure that we do so out of *shraddha* and piety rather than ritual and habit.

Should prayer include namsmarana (*remembering the name of God*), namlekhana (*writing the name of God*) or chanting His name on beads?

All are useful. They take us into consciousness, focusing our mind on something divine. However, each must be done in the right spirit. It is not enough to spend days writing God's name in a notebook. His name must be on our lips, in our hearts, in our thoughts, and not only in our notebooks. If we spend our days writing His name, then what are we doing for the world? Then what is the fruit of this *sadhana*?

Should one recite Gita, Vachanamrut, Hanuman Chalisa regularly each day? If so, how many times per day?

Yes, it is important to recite our scriptures and important prayers like the *Hanuman Chalisa* and other *slokas*. We must recite these as much as possible, so that they become deeply ingrained in our beings. We must recite them so much that we live and breathe them and they become a part of our consciousness.

However, the key to salvation is in how much we live them. In the *Gita*, Lord Krishna says, "*Bhagavad Gita kinchidadhita.*" It means that if we absorb even a small bit of the nectar of the *Gita* and implement it in our daily lives, we will truly be transformed. If we take even one *sloka* of the *Gita*, one divine word of Lord Krishna and actually live it in our daily lives, then we will see the true, divine magic!

Should one sing hymns in praise of one's deity or tell the story of the deity's life?

Katha is important for the same reason that reading the scriptures is. It gives us inspiration and understanding and brings us to the lap of God. But, we must remember that a *katha* is not a social event. A *katha* is about God's word and God's message. That is why we should attend it; not just to see our friends.

How much time during the day should one devote to prayers?

We should devote at least 15 minutes in the morning and 15 minutes at night, but as I said, our entire lives should be devoted to God. Ideally, there should not be a distinction between 'prayer' time and 'work' time; even work can become a prayer. But, in the real world this is difficult, so, at least 15 minutes twice a day.

What should we do if we cannot offer prayer at the appointed time while travelling?

We should not ignore our spiritual lives when our bodies are travelling. Our prayers should be offered as soon as we can. Do not worry about the time change or delay. God never sleeps. He is always awake and always there for you. We do

not have to worry about waking Him up when we reach our destination.

Can prayer redeem sins?

Yes, definitely. However, prayer should not simply be used as an antidote for sin. We should not think that we can sin as much as we want and then pray to ask for forgiveness. That is not how it works. Prayer purifies us so that we no longer commit sins. The *Gita* says, "*Kshipram bhagwati dharmatma*", and "*api chetsu duracharo*". This means that a person who surrenders to God becomes instantly pure and holy. Even a criminal who has committed a heinous crime is instantly purified when he truly surrenders to God.

If a person offers prayers in the morning but does not observe the moral code of conduct during the rest of the day, will he or she benefit from the morning prayers?

Yes, all prayer is fruitful. But, people will also suffer the consequences of their dishonest behaviour. One does not cancel out the other. The real goal of prayer is to make every thought, every action, every word honest and pure and loving. A prayer is the broom which sweeps our hearts. So, when we pray, we should ask God to make us more divine, more holy. Then, we won't have to worry about dishonest deeds.

What should one bear in mind during a prayer?

Prayer has no side-effects, no warnings and no precautions. We should offer ourselves fully to the Lord with no fear or hesitation. That is true surrender. God loves all, embraces all. It is only out of our own ignorance that we fear God. He is the refuge, the salvation.

What kinds of prayer bear fruit and which do not?

All prayers are fruitful. No prayers are ignored by God. However, it is not for the fruits that we should pray. The real fruit of prayer is in connection with the Divine, and that comes with any prayer at any time.

What about people who offer prayers out of fear of God?

On the one hand, it is good that they pray. However, God should never be feared. He is infinitely forgiving, boundlessly loving and always ready to take us into His arms. It is the temptations of the material world that should be feared; it is these that steer us in the wrong direction and bring us frustration and anguish.

Does God heed our prayers? How does one know if God has heard the prayer?

Yes, God definitely listens. But, we must realise that there is a difference between His hearing our prayers and gratifying our desires. God listens to everything we say, however, that does not mean He will always give us what we ask for. God knows what we need; He knows what is best for us, both in the present and for our future growth. So many times we think we know what we want, we think we know what will make us happy. But, only God really knows. Furthermore, what happens in our lives is a product of our past *karmas*, in addition to the goals of today.

So, there are many factors responsible for our prayers not being answered; but we must never confuse an unanswered prayer with thinking that God has not heard us.

How do we know if God has heard us? We must establish

a divine connection, a deep and strong relationship with God. We must have antennae in our hearts that are tuned to only one station: God. Then we will know that not only has He heard our prayers, but also that He is speaking to us. When we speak to God, it is a prayer. When He replies, it becomes meditation.

Is there any difference between a prayer and a thoughtful, moral action? If so, what is the difference?

Yes, there is a difference, but there should not be. All our thoughts and observances should be a prayer. Typically, our thoughts are about relatively mundane things — our selfish desires, our expectations, our plans. A prayer is typically purer, more devotional. The goal, however, is to have every thought focused on God, and to be pure and holy.

What do we do when a sincere prayer does not bear fruit?

As I mentioned before, there are so many factors that are woven together into the fabric of our lives. Our prayers are only one of those factors. *Karma* plays a crucial role in what befalls us, be it success or failure, prosperity or poverty. That is why we must not only be good, but we must also *do* good! The more good we do in our lives, the more our prayers will be fruitful.

Can a prayer which is not supported by action bear fruit?

They say, 'God helps those who help themselves.' In other words, do as much as you can, and then lay the fruits of your work in God's hands. I always say, 'Do your best and leave the rest to God.'

Religious Faith as Basis of Unity

Kumbh Mela is one of the most ancient, yet still alive, festivals of India. Even in the *Vedas* it is described as a tradition that is already well established. Its occurrence is marked by the gathering of millions of people at one of the four holy places — Haridwar, Allahabad, Nasik or Ujjain — the auspicious event occurring at each location once every 12 years.

It is said that even those saints and sages who live in divine isolation, high in the Himalayas, engaged in meditation and austerities, emerge from the mountains to attend the *Kumbh*.

The word *kumbh* literally means 'a pitcher'. The reference is to the pot filled with the nectar of immortality that emerged after the gods and demons churned the ocean. However, the symbolism inherent when we speak of *Kumbh Mela* far transcends the literal translation. A *Kumbh Mela* indicates the beginning of an auspicious and holy event. It also signifies knowledge, happiness and bliss. Our scriptures say:

कलास्य मुखे विज्णु: कण्ठे रुद्र: समाश्रित: ।
मूले तस्य स्थितो ब्रह्मा मध्ये मातष्टगणा: स्थिता: ॥
कुक्षौ तु सागरा: सर्वा: सप्तद्वीपा वसुन्धरा ।
अंगैष्चच सहिता: सर्वे कलष्णाम्बु समाश्रिता: ॥

The above Sanskrit *sloka* tells us that the trinity of gods — Brahma (the Creator), Vishnu (the sustainer) and Shiva (the destroyer) — plus all the goddesses, the Mother Earth with her seven islands, and all knowledge in the form of *the Rigveda, Yajurveda, Samaveda* and *Atharvaveda* exist in the *kumbh*. Thus *kumbh* is the symbol of all that is and all that exists. The *Kumbh Mela* is a celebration, a festival of the glory of *kumbh*.

Astrological and Scientific Background

Indian festivals are not only filled with gaiety and joy, but invariably have a solid scientific and historical foundation, leading to physical rejuvenation, psychological healing and spiritual upliftment.

It is according to scientific and astrological methods that the place and date of each *Kumbh Mela* is determined. When the planets, the sun and the moon line up in a particular manner, a positive charge occurs in the atmosphere of one of the *kumbh* locations. This positive charge affects the water, the air and the entire atmosphere, such that being at that special place and taking a bath in the holy waters proves exceptionally conducive to spiritual growth, and to physical and emotional well-being.

The *Kumbh Mela* is not simply a theoretical ritual that is followed blindly. Rather, it is a scientific, historical and thoughtful tradition of the Hindu culture.

The origin of the *Kumbh Mela* lies in the churning of the ocean in search of the nectar of immortality. The fight between

good and evil has existed from time immemorial. The demons were always fighting with the gods. However, the gods did not want to fight; they remained peaceful and calm. This did not deter the demons from killing them, Hence, the forces of good began to fall to the forces of evil. One day, the *devas* went to Lord Brahma and said, "We are losing so many of our brothers and sisters in the never-ending war with the demons. If this continues, none of us will be left. Please help us." Lord Brahma told them to go to Lord Vishnu.

Lord Vishnu listened to their story and sympathetically responded, "If you churn the great ocean, you will find a gold pot of nectar. The drinker of the nectar will be blessed with the boon of immortality. However, you are not strong enough to churn the ocean yourselves. You must attain the help of your brothers, the demons."

The gods were in great distress. "But, Lord Vishnu," they said, "if the demons know that the reward of churning will be immortality, they will take the nectar all for themselves. Then we will be in even more trouble. Alternatively, if we hide from them the reason, they will never agree to help us."

Lord Vishnu assuaged them and told them to simply go and request help from the demons. So, the gods left the abode of Lord Vishnu and successfully convinced their demon brothers to help with the task. The churning of the great ocean by the gods and the demons became a momentous event. The rope required for churning was offered by the snake Vasuki, and Lord Vishnu himself became a huge turtle, on whose back they could easily churn.

So, the fantastic churning began with the hope of divine

 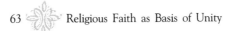

nectar filling the minds of the gods. However, after a great deal of effort, what emerged was not nectar, but poison!! The gods and demons knew that in order to continue churning, they could not simply toss the poison aside. Someone had to drink it. So, a conflict began. Who would drink the poison and thereby allow the historic churning to continue? No one would agree to sacrifice himself, until Lord Shiva came forward and said, "I will drink the poison if it will preserve peace and enable my brothers and sisters to attain the nectar of immortality." The sacrifice Lord Shiva made is an example of why He is *Mahadeva* and all the other gods are simply *devas* — selfless dedication to the welfare of others.

At last, out of the murky water emerged 14 precious jewels. At the end, Lord Vishnu himself appeared, holding the precious *kumbh* in his hands.

However, Indra — the king of the gods — knew that the demons were planning to abscond with the treasure of immortality. So, he immediately signalled to his son, Jayant, who leapt forward, grabbed the pot of nectar and quickly ran away. The demons, however, were stronger and quicker than Jayant and they pursued him relentlessly. Indra sought help from Jupiter, Surya, the moon and Saturn to protect his son and preserve the *kumbh*. The long chase lasted 12 days, which was the equivalent of 12 years on the earth. During this chase which traversed the realms of the earth, the heavens and the moons — Jayant rested only four times. While resting, he placed the *kumbh* on the ground and a few drops of holy nectar spilled onto the earth in each place. These four places have now become the four centres of pilgrimage for the *Kumbh Mela*.

Kumbh Mela as a National Event

In order to unite the entire nation of India, a festival must appeal to two distinct strata of society — the intellectual, educated class and the average, less educated and more superstitious class. Religious faith is the basis of unity in spiritually inclined people. Spiritual people seek those things which will help them progress further towards the ultimate goal. Our sages understood this, and thus, mythological stories appeal to the masses, and the philosophical message and scientific basis attract the educated mind.

Rishis and sages have always shouldered the responsibility of the social, moral and spiritual upliftment of the country; they have dealt with problems of invasions, corruption, lethargy and selfishness. The nectar, which manifests in the form of *satsang*, knowledge, love and grace, is distributed to all, without discrimination. The great assemblages of *sanyasins*, *yogis*, sages and saints reassure and uplift the nation; hence masses of people rush to the sacred places at the time of the *Kumbh Mela*. Mahatma Gandhi, in his autobiography, writes, "And then the *Kumbh Mela* arrived. It was a great moment for me. I have never tried to seek holiness or divinity as a pilgrim, but 17 lakh people cannot be hypocrites."

Even today, the *Kumbh Mela* requires no advertising. Indian calendars simply note the time and place of the next *Kumbh Mela* and millions of people flock there with unshakeable faith and devotion. One cannot even imagine the challenge of organising such a function and yet it just happens by the grace of the words '*Kumbh Mela*'.

The entire world has turned to India for spiritual

guidance. Our culture may not be materially advanced, but our scriptures have long taught the message that is urgent for today's world. For example, India is the only land where rivers, mountains, trees and animals are not only respected, but worshipped.

In today's age of environmental awareness and ecological conservation, everyone knows that mountains, rivers and trees are natural resources which must be preserved, conserved and used wisely. We have seen the devastating consequences of deforestation, over-industrialisation and pollution of our water sources. No one can be blamed for this travesty other than ourselves. It is the Hindu culture that has preached reverence for Nature since its inception so many thousands of years ago.

Rivers, especially the Ganga, are truly our mothers. Farming is a primary occupation in India; thus, irrigation is of utmost importance. The Ganga and other rivers irrigate not only our farms but also our hearts, minds and souls. It is to our sacred rivers that pilgrims flock for the *Kumbh Mela*; yet, we must remember that these rivers and mountains are sacred and treat them as such. The message of the *Kumbh Mela* of present times must include a renewed care for the land we call 'mother'.

Present in Manifest and Unmanifest Forms

A Hindu temple is a sacred place, endowed with divine energies and powers. In the heart of each temple are the deities to whom we bow and pray in worship. Why is it, though, that these statues, these idols, are worshipped as God? How did they come to be infused with divine characteristics? The answer to this is the *prana pratishtha* ceremony.

People say that Hindus are idol worshippers. We are not; we are ideal worshippers. It is not the plaster or marble or stone we revere; rather it is the presence of God transmitted into these otherwise lifeless statues. The rites and rituals of *prana pratishtha* are followed strictly according to the *Agamic* texts. Prior to installation, priests, well trained in Vedic rituals, perform specific *mantras* and *puja* to endow an inanimate object with divine life and energy.

These *mantras* and rites begin with the sculptor who carves the stone. He is not an ordinary artist; rather, he is one blessed with the ability to create a physical manifestation of God. He performs a *puja* and prayer prior to and during

sculpting. He maintains in his mind the vision of the deity he is sculpting. He prays for this God to come to life in his statue. His work area looks more like a temple than an art studio. So, from that moment the stone is treated with reverence and piety, to prepare it to carry the force of God.

Then, when the statue is finished and taken to the temple, the special *prana pratishtha* ceremony lasts for five days. During this time, numerous rites and rituals are performed with the chanting of *mantras*. Now the idols become infused with divine power and truly embody the God in whose manifest form they are created. Now they are treated as deities. After this, we no longer refer to the stone or other materials of which they are constructed. They have now become sanctified and are a physical manifestation of the supreme Godhead. "Whatever form of me any devotee worships with faith, I come alive in that form," says the *Bhagavad Gita*.

Some people may ask why we need deities, if God exists everywhere. It is very difficult for most people to envision the formless, ever-present, all-pervading Supreme Being. It is easier for us to focus our attention and our love on an image of Him. It is easier to display love, affection and devotion to a physical deity than to a transcendent, omnipresent existence. So, by worshipping His image with faith and love, we reach His holy feet.

In the *Srimad Bhagavad Gita*, Lord Krishna says, "Whenever one develops faith in me, in my manifest form as the deity or in any other of my manifestations, one should worship me in that form. I exist within all created beings as well as separately in both my 'un-manifest' and manifest forms. I am the supreme soul of all."

Worship of the Mother

One of the most important aspects of Hinduism is reverence of *Shakti*, in all her myriad manifestations. However, although there are truly infinite ways to thank and worship the mother, I feel that three ways are most important. These three aspects are: Our mother, our motherland, and our mother tongue.

Our Mother

A mother is truly divine. It is from her womb that we have emerged. Our life is a gift from her; our nourishment has flowed from her body. The love that sustains us, that embraces our soul, ceaselessly streams from her heart.

When I say our 'mother', I mean many things. Of course, I mean the actual mother who gave us birth, but, I also mean the divine mother of all — the goddess. In this mother, we find not only our own mothers, but mothers everywhere. We find Mother Nature, Mother Earth, Mother Ganga.

These mothers must be seen as divine. For our own mother, this means treating her with respect, with love, with patience.

I know that when we were young, we tended to take our parents for granted, or become frustrated at their attempts to teach us. We must not do this. We must find in our hearts, her own blood and her own life. For that is how we are connected.

For Mother Nature and Mother Earth this love and respect means protection. Mother Earth has given us all that we need to sustain our lives, but we tend to destroy her. Let us treat our earth as a mother. If our own mother were sick, we would not let her simply suffer, decay and die. We would fight tenaciously to bring her back to health and glory. Let us give the same to the real mother. We must not pollute her or waste her. We must nurse her back to health.

Motherland

Be Western (if you live in the West) when it comes to professional excellence, but be Indian in your domestic life and in your heart. The West has a great deal to teach in terms of external perfection — especially in the professional arena. But we must not lose our souls in this attainment of external success. Our bodies and our brains may be in the West, but our spirit must stay with our motherland.

How to do this? Firstly, have a 'happy hour' in the evenings. But make it an Indian 'happy hour'. Make it an hour whose happiness lasts even when the 60 minutes are up, a happiness without a hangover, a happiness that runs through the soul, and not just through our bloodstream. The real 'happy hour' is *puja*, *aarti*, being with the family. We spend so many hours each day being perfect in the Western sense.

Spend at least one hour being *Indianness*-devoted. Then, we can see the real magic.

Mahalaxmi is the goddess of wealth. We pray to Her for prosperity. Yet, our real wealth lies in our heritage, in our roots, in the ancient wisdom of our scriptures. Let us not forsake the everlasting richness of our culture in favour of transient material possessions. Before we pray for more wealth, let us treasure the wealth we have already been given. That is real prosperity.

Mother Tongue

This is the language of our soul. Our brain may think in English, our mouth may speak in English, but our soul speaks in Hindi or Gujarati or Punjabi or Tamil or Kannada or Sindhi. We cannot cut ourselves off from the words of our ancestors, for much of the wisdom and clarity is lost in translation.

A dog does not have to learn how to bark; a cat does not have to learn how to mew. A cow does not forsake her own natural 'moo' nor does the chirping of birds ever stop. It is wonderful to learn English and French and Spanish and German. These languages will be of great help in our academic and professional lives, but, our mother tongue is the thread that connects us to our roots, our family, our true essence. Do not sever this connection, for it is the tube through which our life-blood flows. How can we truly know a culture, be part of a heritage, if we cannot speak its language?

Protect Living Beings

Teaching a child not to step on a caterpillar is as valuable to the child as it is to the caterpillar.

We make many choices in our lives without ever questioning them. Choices like which religion we believe in, what our values are, what we eat... perhaps, we simply continue to live the way we were raised; perhaps, we automatically adopt our parents' choices. Or perhaps, we rebel against how we were raised: our parents made one choice, so we will make the opposite. In either case, we rarely take the time to see why we are living the way we are.

In this article, I want to take the opportunity to see why we should live as vegetarians. I want to talk about the deep meanings behind the choice we make each time we put food in our bodies.

I hear so many Indian youth tell me, "But my parents can't even give me a good reason to be vegetarian. They just say that the cow is holy, but if I don't believe the cow is holy, then why can't I eat hamburgers?"

The importance of vegetarianism far transcends the belief that the cow is holy. In fact, although the tenet of vegetarianism is as important as it was ages ago, the reasons for it being so have changed slightly. Some of the meanings and reasons are the same today as when our scriptures were written thousands of years ago. However, many of the reasons are directly related to the world we live in now. While vegetarianism has always been a correct moral and spiritual choice, today it is more than that.

Today, it is an imperative choice for anyone who is concerned about the welfare of Mother Earth and all the people who live here. Today, it is not only a religious decision. Rather, it is the only way we can hope to eliminate hunger, thirst, rain-forest destruction and the loss of precious resources. It is, in short, the most important thing that each man, woman and child can do every day to demonstrate care for the earth and care for humanity.

Aspects of Vegetarianism

One of the most important guiding principles of a moral life is *ahimsa*, or non-violence. There is hardly anything more violent than taking the life of another for our mere enjoyment. It would be one thing if we were stranded in the jungle, starving to death, and we needed the food to survive. But, we live in a world where we can get all our calories, all our vitamins and minerals in other tastier, less expensive and less violent ways. Hence, to continue to kill animals is simply to fulfil our desires, our pleasures. It is simply selfish gratification at the cost of incredible pain to another.

Perhaps more violent than the day of death of these animals are the numerous days of their lives. The animals raised for consumption are raised distinctly differently from animals raised as pets, or raised for their by-products (e.g. milk from a cow). Veal is a poignant, compelling example. Its meat is considered a rare delicacy by people across the world. Tender veal cutlets are frequently the most expensive item on a menu. Yet, when we look at the way in which the animal becomes so tender, we realise that the true price of this dish is far more than what the restaurant charges.

Veal is the meat from baby-cows who are separated from their mothers immediately at birth. Cows, as milk-giving/breast-feeding mammals have very strong maternal instincts. It is not a simple coincidence that Hindus worship the cow as mother. A mother-cow will keep her calf next to her long after he is born, looking after him, protecting him and teaching him to fend for himself. But, these baby cows are wrested from their new mothers. I have heard from people who have visited these places that, contrary to what the meat industry will tell you, the mother and baby cows cry in agony for hours after being separated.

It is essential that the babies do not develop any muscle, but if they stand near their mothers, their legs develop muscles. And the muscle is hard; fat is soft and juicy. Fat is tender. The difficulty is that if one uses one's limbs at all, one develops muscles. So, the only way to prevent development of the muscles is to prevent the use of the limbs. So, these newborn baby cows, screaming for the warmth of their mother's breast, are locked in restraining boxes. Their entire bodies are

restrained by chains. If you have ever tried to move a foot or a hand that is chained, you will know that it is impossible to do so, especially if you are a baby with no muscle. They are fed copious amounts of food, more than babies should theoretically eat, so that they will become fat quickly. However, they are never removed from the confines of the restraining box. And this lasts not one day, not one week, but many months, until they are killed and sold as 'tender veal cutlets'. So, what is the real price of this dish?

Now, let's look at chickens. Many people (especially in the West) say they are vegetarian, but they still eat chicken. The life of a chicken is only scarcely better than the life of the baby cow. They are put in crates, which are piled high on top of each other. In this way, they are denied space to move, let alone roam around. The crates are never cleaned and the chickens never see sunlight; light from artificial bulbs is enough to keep them functioning.

Chickens — like humans — have a natural need for territory and space. These needs are unmet in chicken 'farms'. Rather, these animals are packed together as closely as possible, such that they frequently cannot even move. To gain a true understanding of these conditions, picture yourself in an elevator, which is so crowded that you cannot even turn around, let alone move. Picture as well that all the people in the elevator are confused and scared. They do not realise that there is no way out. So they cry and bite and kick in a frenzy, attempting to free themselves from this claustrophobic terror. Next, imagine that the elevator is tilted, so that everyone falls to one side, and it is nearly impossible to get up. In this

elevator, the ceiling is so low that your head gets pushed down into your shoulders in order for you to be able to stand. There is no way to straighten your neck. And you are all barefeet on a wire floor that pokes and cuts into your feet — ever so sensitive, for you are probably only a few months old. Finally, imagine that this terror does not end when someone comes to open the door at the lobby floor. Rather, this is your life. Every minute of every day, until you are fried and served for dinner, with mashed potatoes.

Integrity and Honesty

How many of us are always honest? How many of us can say that we do not lie? We would like to believe that we are righteous, honest people and are passing these values on to our children. Well, if we eat meat, we cannot say that we do not lie. In fact, our life is a lie. Here is why: if we wanted to be honest and still eat meat, we would have to go outside, chase down a live cow and bite right into it. Or we would have to go to one of those chicken 'farms', take the animal while it is alive, tear off its head, pull out its feathers and eat it raw. Of course, we do not do that. Instead, we order a hamburger. We cannot even call it what it is, let alone kill the animal ourselves. So, we call it beef instead of cow. We call it pork instead of pig. We call it poultry instead of chicken. And we eat it packaged in neat, nice ways that allow us to forget what we are eating.

How many people stop and think that the thing between the tomato and the bread on a hamburger was once a living creature? That it was someone's child? How many of us

would eat our cats or dogs between a piece of tomato and a slice of bread? We wouldn't. And that is why it is a lie. We cannot even admit to ourselves what we are doing. How then, can we consider ourselves honest people if we are lying every time we eat? And these are not lies that only cause misunderstanding; these are not white lies. These are lies that are killing our planet, our animals and ourselves.

The Taste of Fear

Additionally, eating meat is violent not only to the animal whose life we are wresting from it; it is also violent to our planet and ourselves. This violence manifests in other, more subtle ways. When animals (humans included) are threatened, we secrete large amounts of hormones. These hormones are frequently referred to as adrenaline. Their purpose is to prepare our body to fight, to save our lives. Have you ever noticed that when you get scared, a lot of things happen inside you? Your heart beats faster, your digestion is disturbed, your palms sweat and your physical impulses become sharp. These are a result of the hormones. And they prepare us to either fight or run away. Thus, they are sometimes called 'fight or flight' hormones.

When an animal is about to be killed, its body gets flooded with stress hormones, which remain in the animal's tissues. So, when we eat those tissues, we ingest those animal hormones (which are the same as our own bodies make). Thus, our bodies become flooded with these 'fight or flight' chemicals, making us more prone to simple survival instincts.

Our world is becoming more violent each day. More and

more people are simply out to get ahead, even at the expense of others. These are the same characteristics that adrenaline and other stress hormones prepare our bodies for. Hence, is it not possible that the increase in these characteristics worldwide, is a direct result of the increase in meat consumption and the subsequent ingestion of stress hormones? I think it is.

So, if we truly want to reduce violence and hatred in this world, perhaps we should stop flooding our bodies with hormones that create stress and the readiness to fight. Perhaps, if we treat our body like a temple, it will behave and think like a temple. When we treat it like a battleground, why then do we wonder when it acts like a battleground?

Vegetarianism and Ecology

Aside from all the compelling moral and spiritual reasons, vegetarianism is the only responsible choice in terms of waste and the ecology. The natural resources of our planet are diminishing at a terrifying rate. More than a third of the world goes to bed hungry each night. And we wonder what we can do. Vegetarianism addresses most of the ecological issues.

Are you concerned about *world hunger*? Let me give you some facts.

- It takes 16 pounds of wheat to produce one pound of meat. This wheat is fed to the cows who are later killed for giving us beef. However, it takes only one pound of wheat to produce one pound of bread. So, if we use our wheat to produce bread rather than feed

it to cows in order to make hamburgers, we could feed sixteen times as many people.

- An acre of land can grow 40,000 pounds of potatoes. That same acre can provide less than 250 pounds of beef if it is used to grow cattle-feed.

- If the West reduces its intake of meat by 10 per cent (it means they would still eat 90 per cent as much meat as they do now), we could feed every one of the 50,000 people who die of starvation daily.

- Every day 40,000 children starve to death. Every day the US produces enough grain to provide every person on earth with two loaves of bread.

- Today, 840 million people go hungry every year.

- We could feed 10 billion people a year if we were all vegetarian — that is more than the world's entire human population. There is no need for anyone in the world to go hungry but selfishness is the choice we make.

Are you concerned about destruction of the rain-forests and other precious land?

- A great deal of livestock is raised on forest-land. It is estimated that for every hamburger, 55 square feet of rain-forest land is destroyed.

- For one hamburger, 500 pounds of carbon dioxide (the main gas responsible for global warming) are released into the air.

- Since 1967, one acre of American forest gets destroyed every five seconds in order to become grazing land

for the animals that will become man's dinner. If the present trend continues, the country that was seen as the 'land of plenty' will be stripped bare of all its forests in 50 years. Let not Europe make the same mistake.

Are you concerned about *poverty* in the world?

- A pound of protein from meat costs $15.40, but a pound of protein from wheat costs $1.50.

- Meat costs 10 times as much for the same nutritional value.

- Can't money be used for a much better cause than to kill animals?

Are you worried about our rapidly diminishing *energy resources*?

- The world's petroleum resources will last only 13 years on a meat-based diet, but 260 years on a vegetarian diet.

Are you aware of the need to conserve water?

- The production of one pound of beef takes 2,500 gallons of water.

- The production of one pound of bread takes 25 gallons of water.

So, we would waste 100 times less water if we ate wheat instead of meat.

Health Issues

I am not going to use this space to tell you about the health

reasons to eat a vegetarian diet. Every medical text, every health book talks about the undeniable link between a high-fat diet and heart disease or cancer. It is well known that people who eat meat-based diets have anywhere from twice to 20 times higher rates of death due to heart disease and cancer than do vegetarians.

A recent British study found that vegetarians had a 40 per cent lower risk of cancer and a 20 per cent lower risk of death from any cause than did meat-eaters.

In fact, Dr Dean Ornish, M.D., a cardiac specialist in California, USA, is the first allopathic doctor ever to be able to 'cure' heart disease. Others have slowed the process but never before has it been truly cured. His 'cure' consists of a pure vegetarian diet, yoga and meditation.

A health issue not often discussed is the antibiotics factor. The animals we consume are loaded up with antibiotics in order to prevent diseases. Their environments are so unsanitary that the animals face a severe risk of developing infections. So, they are fed antibiotics in large quantities. When we eat these animals, we ingest the antibiotics as well.

However, bacteria are resilient. They develop resistance to antibiotics, whether taken directly or through the meat of an animal who has taken them. Hence, when we ourselves are sick and actually need the antibiotics, they do not work. This is because our bodies have already developed resistance to them due to years of meat consumption.

Each year more and more antibiotics become futile and powerless; each year there are more and more resistant strains of bacterial infections. Many people believe that the reason

for this is that as we have been consuming low doses of antibiotics for so many years through our consumption of meat, bacteria have had a chance to mutate and become resistant to them.

Another issue has to do with hormones. Animals are fed large doses of hormones to make them fatter, bigger and juicier. There is substantial evidence that over-secretion of hormones within our own bodies leads to disease. For example, over-secretion of adrenaline and the stress hormones can lead to heart disease. Over-secretion of oestrogen is associated with cancer in women. Yet, when we eat meat, we consume the same hormones.

We are thus not only eating meat, we are also eating hormones that our bodies don't need and that may put our life and health in jeopardy.

Across the industrialised world, everyone is talking about saving the planet. Ecological conservation has become a household word. There are thousands of programmes dedicated to feeding the millions of starving children. We may not be able to carry crates of food to the deserts of Africa. We may not be able to re-plant every tree that has been cut down in the forests. But we can strive to make at least our lives and our actions pure and divine. Instead of a token donation to a hunger campaign or to an environmental organisation, let us partake of meals that protect not only our own health, but also the health of our planet and the health of every person on it.

The Divine Hand

Hinduism is, at its very core, a religion of unity, a religion of inclusion. Our scriptures teach '*vasudhaiva kutumbakam*' or 'the world is one family.' The *Upanishads* say, '*Ekam sat viprah bahudha vadanti*,' or, 'The truth is one, but the paths are many.' The scriptures explain the difference between the various paths, but never hold one in higher esteem than another. Thus, there is no place in our culture, tradition, faith or religion for exclusion, for prejudice, or for an 'us vs them' mentality. One of the great pillars of Sanatan Dharma, and one which has helped it to withstand the test of time, is its unity in diversity, its ability to embrace innumerable sects in its arms.

Unfortunately, today we are seeing these very basic principles of unity uprooted and undermined. It is not only other religions and faiths against which our people seem to be discriminating, but this discrimination is even taking place against members of our own Sanatan Dharma! Today, as I travel the world, I hear people make comments like, "Oh, we are not part of that *katha*, organised by the other temple," or,

"Our Janmashtami programme is held here and their programme is held over there," or, "I won't go listen to that saint speak. He is not from our *sampradaya*." I hear constant complaints and criticisms from one group about the other. Suddenly, the foundation of our great tradition seems to be shaking. This is a great tragedy.

God is one — ultimate, omniscient and omnipotent. He manifests at various times throughout the history of the world when darkness overpowers light, when evil conquers righteousness, when *adharma* wields its insidious hand over *dharma*. Depending upon the time and the needs of the people, God incarnates in such a form as to benefit all mankind.

The same is true of personal worship — God appears to each of us in the form which is most suited to our personal spiritual development. Lord Krishna says, "*Ye yatha maam prapadhyante*," or 'Whichever form the devotee worships, in that form I appear.' This does not make that particular form inherently or objectively 'better' than the others. It merely means that it is the form which will be easiest for us to relate to and worship.

Additionally, as we talk about the various paths to God — including *gyan*, *bhakti* and *karma* — which manifest in today's world as various branches of teaching, none is objectively superior to the other. Certain people are more inclined towards scriptural study and philosophy. Others are more inclined towards selfless service and humanitarian work. Still others are more inclined towards blissful love of God and devotional practices. For each of these paths, there are numerous branches, sects and schools of teaching. In this way,

each can find a particular group with whom to relate, a particular temple in which to worship and particular practices which appeal most to their own, inherent sensibilities.

However, it must be remembered that this flexibility of Sanatan Dharma allows the maximum number of people to achieve the ultimate goal of realising God.

Hinduism is the tree of life. Each of us lives on a particular branch and eats the leaves of that branch for our nourishment. But, we must not cultivate the belief that our branch is superior in any way to the others. Nor must we mistake our branch for the tree itself. No branch is the tree. Only the tree is the tree. Yet, all branches are intricately connected to this tree and depend upon it for their very survival. An isolated branch, split away from the tree, will quickly become desiccated and perish. It is only by remaining connected to the tree that a branch can survive.

Therefore, let us all choose our personal method of worship. Let us have our personal *ishta devta*. But, let us not forget that it is the tree which sustains us, not the branch. That tree is Sanatan Dharma. That tree is our Indian culture. Every branch stems from the same great trunk. Our roots are the same; it is the same soil which nourishes us. Thus, let us remember that we are *not* separate; rather, we are one.

The various Hindu sects must function like fingers of a hand. Sure, one is longer, one is shorter. One is closer to the left, one is closer to the right. One is narrower, one is wider. But, they are part of the same hand. Only by working together as a hand can any beneficial work be done. A finger by itself is virtually powerless. It is only by working in conjunction and

cooperation with the other fingers and with the rest of the hand that all the fingers' potential is realised.

Similarly, all the Hindu sects are individual fingers — separated slightly, different in outward appearance. At times, they may stay apart, but when necessary, they come together. They are part of one divine hand and they must work together for their own benefit, for the benefit of Hinduism and for the benefit of the world.

Experience the Sacred Energy

A temple is not merely a building. It is the abode of the Lord.

- A temple's strength is not in its bricks.
- Its fortitude comes from the dedication of its members.
- A temple is not held together by plaster and mud.
- Its glue is the piety and devotion of the community.
- A temple is not simply a place we visit.
- *It should be the axis around which our lives revolve.*

People may ask, "If God is everywhere, if every living being is a manifestation of Brahma, then why do we need to go to a temple?" There are many reasons. The most important reason is that a temple is not only the home of God, but is a concentration of divine energy.

During the installation of the deities (*prana pratishtha* ceremony), the idols become powerful manifestations of God.

The priests chant special Vedic *mantras* and perform special sacred rituals which endow these deities with divine attributes and powers.

Therefore, praying before a deity in a temple may give us a greater sense of being in the presence of God than praying in our own homes.

Additionally, the temple building itself is constructed in such a way as to maximise the concentration of positive, sacred and peaceful energies. The actual structure of a temple is said to represent the resting body of the Lord. The sanctum tower (*vimanam*) represents His head, the door of the sanctum is His mouth, the entrance tower (*raga gopurum*) is His holy foot, and other parts represent His limbs. And, most importantly, deep inside the main structure is the sanctum sanctorum (*garbha griha*), which is the heart of the Lord, and it is there that we place the deities.

Ancient *rishis* and saints could realise God through meditation. They lived high in the Himalayas or in secluded forests, where distractions were few and their lives were focused on one thing — attaining divine vision. They, therefore, did not need temples; their world was their temple. However, today, our lives are flooded with material desires, with mundane tasks, with logistic concerns. We must get up each day and go out to earn a living to feed our families. We must live in a world that indoctrinates us to crave only sensual pleasures and material wealth. It is very difficult for this world to seem like a temple. Therefore, we must have a place which is sacred, a place which is holy, a place in which our sole purpose is to become one with God.

A university student may claim he does not need to go to the library to do his homework — his dormitory room is a fine place to study. Theoretically, that is true. The books are

the same, the material to be learned is the same. However, we know that in a dormitory room he will be distracted constantly by the ringing of phones, by knocks at the door, by loud music, by the desire to gossip with his friends in the hallway.

However, the library is a quiet corner. It is a place devoted to academic studies. In the library, wherever we look, we see other students deep in their work. This environment provides us not only quiet in which to study, but also inspiration from others who are there for the same purpose.

Similarly, we go to a temple for the sacred environment, for the holy energy in the building itself, for the divine presence of the deities, as well as for the inspiration from others who are focused on God.

However, a temple should not only be a place in which we worship. It should become the focal point of our lives. The temple should be the place where children come to learn about their heritage as well as to play with their peers. The temple should be a place of celebration during times of joy, as well as a place of comfort and solace during times of grief. A temple should feed every aspect of our being: our heart, our mind, our stomach and our soul.

Truth is One, Paths are Many: Questions and Answers

*W*hat is your favourite holy scripture?

There is a galaxy of holy scriptures, each with its own solar system of stars and suns. Each contains an unparalleled wealth of wisdom and inspiration from our *rishis*. These scriptures are the lamps that shine brightly on the path of righteousness and truth, guiding our way in the dark of the night.

However, if I had to choose one, I would say it is the *Bhagavad Gita.* As Paramhansa Yogananda said, "The *Bhagavad Gita* is the most beloved scripture of India, a scripture of scriptures. It is the Hindu's holy testament; the one book that all masters depend upon as a supreme source of scriptural authority." The *Gita* provides wisdom and upliftment, comfort and solace to people of all ages, from all walks of life, from all corners of the earth.

Bhagavad Gita literally means song of the spirit, song of the soul, song of God. Like any truly divine song, the language

of the original lyrics and the religion of the original singer are irrelevant. For, once it has been written and sung, the song itself comes alive, bursting forth across oceans and mountain ranges, breaking all barriers of caste, creed and nationality. Such is the power of a divine song. However, as the original 'singer' of the *Gita* was Lord Krishna, this is the holiest and most sacred of all the songs of God. Therefore, its power to transform, to heal, to uplift is as limitless as the singer Himself.

It has been said that the *Upanishads* are the cows while Lord Krishna is the cowherd, Arjuna is the calf and the *Gita* is the milk. But, it is not just any milk. This milk is nectar that flowed from the gods with the power to heal the sick, comfort the lonely, guide the lost, uplift the fallen and bring peace to the troubled.

How and when were you introduced to this holy scripture?

I was introduced to this incredible work by my spiritual master, when I was eight-years old. The *Gita* was his favourite text and he used to carry it everywhere with him. He called it the most important piece of wisdom for everyone, regardless of education, caste, or spiritual aspirations. When he initiated me, he gave me my own copy — a small, simple version in original Sanskrit. I learned Sanskrit through the *Gita*, memorising it in its entirety. In that way, Lord Krishna's message and His language came alive for me simultaneously.

How much time do you devote each day to the Gita?

Approximately an hour each day. But in the beginning, in my early years, it was my life. Every minute of my day was spent in either meditation, *japa*, or contemplation of God and the *Gita*. While I may only spend an hour each day to study

the *Bhagavad Gita*, I spend all 24 hours living the *Gita*.

What is the Bhagavad Gita's impact on your life?

The *Gita* has made me *ast*, *vyast*, *mast* and *swasth*. What do I mean? First, I became *ast*, emerged in God. I was like the sugar that, when mixed in water, loses itself and becomes one with the water.

The *Gita* became the blanket that wrapped itself around me in the cold and the dark of the night. I was alone in the forest and became completely immersed in Lord Krishna. His words spoke to me through the *Gita*, through my *mantra*, and through His own voice. They comforted me, taught me and guided me.

Then, as I studied the message and the wisdom of the *Gita* more, I learned how to be *vyast*. *Vyast*, in essence, means 'doing is being, and being is doing'. This is Lord Krishna's message. So many people today assume that a spiritual path is one of idleness, one of silent contemplation high on a mountain top. But Lord Krishna teaches that we should be the hands that do God's work — this is *karmayoga*. We should not only be divine, but we should do divine. But again, *vyast* is a different kind of 'doing' than most people do. It is 'being' while 'doing'. What does this mean? It means treating work as a prayer, as meditation. We should have His name on our lips and in our heart, and His work on our hands.

From *ast* and *vyast*, I became *mast* — ever happy, ever joyful, ever blissful. When we are immersed in Him and His work is flowing through us, what else can we be?

When we are *ast*, *vyast* and *mast*, we automatically are

swastha, or completely healthy, and in perfect balance. But *swastha* does not imply only perfect physical health; rather, it implies health of the body, the mind, the soul and the spirit. Every pain, every ache, every discomfort becomes *prasad* as we lay it in His lap. His love and His presence dissolve all our hurts, both within and without. Our body and our soul become one in perfect harmony.

How do you convey the message of the Gita to your devotees?

The *Bhagavad Gita* is not abstruse. It is intricate and deep, but not complicated or difficult. Its messages are clear. Through the story of Arjuna in the battle-field, Lord Krishna gives us lessons for our lives. The real Kurukshetra is within us. Each of us is Arjuna, struggling with right and wrong, temptation, fear and frustration. Our bodies are our chariots, being driven all too frequently by our senses as the horses. The mind, ego, desires, lust and greed are the evil Kauravas with whom we must do righteous battle, from whom we must not shy away in fear and trepidation. If, instead of letting our chariots be driven by our senses, we give the reins to Lord Krishna, we will surely be victorious.

Additionally, the central message of the *Gita* is to perform our duties diligently and piously, but without any expectation of what the results will be. We must till the soil, plant the seeds, water and tend to the seedling, and take care of the tree without any thought of how much fruit this tree will bear. We are God's gardener, carefully tending the garden but never becoming attached to what will blossom, what will flower, what will give fruit or what will wither and die. Expectation

is the mother of frustration, but acceptance is the mother of peace and joy.

Lord Krishna says, "Stand up! Do divine! Be divine! Don't expect, but accept!" Life is a journey, not the destination. If the reins of our life-chariot are in His hands, we will be ever happy, ever peaceful. This is the lesson of ultimate surrender that I convey to my devotees. Put all your assets in the Divine's insurance company, and you will always be taken care of.

How relevant is this message for today's life?

The message of the *Gita* is as relevant for people living in the East or the West today as it was for the people of India more than 5,000 years ago. It is as relevant for Hindus as for people of all other religions. It teaches Hindus how to be better Hindus, but it also teaches Muslims to be better Muslims, Christians to be better Christians and Jews to be better Jews. For, if something is really the 'truth', it must be universal. Truth is not limited to a religious framework. If it is the truth, it must pertain to all. Such is the profound truth of Lord Krishna's words.

The *Bhagavad Gita* does not discriminate between different religions and provides light and inspiration not only to the Hindus' minds and souls, but to all human beings.

Is the Bhagavad Gita useful for people in the West?

Definitely. Aldous Huxley has said, "The *Gita* is one of the clearest and most comprehensive summaries of the perennial philosophy ever to have been made. Hence, its enduring value is not only for Indians, but for all mankind."

Perhaps people in the West actually need this wisdom even more. People in the West seem to hold on ever more tenaciously to their agendas, their expectations, their desires. The message in much of the West is: 'If you work hard, you will succeed, you will become prosperous.' So, people don't work for the sake of being God's hands. They work to reap the benefits, and when the benefits don't come or don't come quickly enough, they get frustrated.

Hence, it seems people in the West need both the message and the comfort of the *Gita* a great deal. Mahatma Gandhi has said, "When disappointment stares me in the face and all alone I see not one ray of light, I go back to the *Bhagavad Gita*...I immediately begin to smile in the midst of overwhelming tragedies and my life has been full of external tragedies. If they have left no visible, indelible scar on me, I owe it all to the teachings of the *Bhagavad Gita*." The lives of people today seem coloured by indelible scars. I hope they will all turn to the *Gita* as the remover of pain and the bestower of light.

All the time you are on the move. Do you find time to read the scriptures of other religions as well?

Definitely. I have read the major scriptures of most religions. I feel that the truth is one, although the paths are many. Therefore, each path, each religion has great value for me. I have read *Shri Guru Granth Sahib*, the holy book of the Sikhs, the Quran and the Bible, as well as numerous other religious works from other religions.

Do you compare these works?

No. Every book gives an important message and the

messages are the same; only the language is different. Each work teaches the message of 'love all, hate none; heal all, hurt none.'

If you don't fully understand something (say, another religion, you should never criticise it. Instead of criticising the principles of others, our energies should be spent on following the guiding principles of our own religion. That is what will lead to health and happiness, peace and prosperity.

How can the Bhagavad Gita be useful in achieving salvation and self-realisation?

The *Gita* provides the guiding principles for both peace in this life as well as for ultimate salvation. When I was in Japan, I saw a sign that said, 'Follow the rules, and enjoy your stay.' While it is simple and trite, it is true. The rules for our lives are laid out in the scriptures: do divine, be divine, serve without expectation, love all, surrender to God. When we follow these rules, our lives become infused with joy, love and peace. It is when we ignore these commandments or amend them to suit our own agendas that we bring pain and turmoil into our lives. The *Gita* is a complete yet concise listing of all the teachings necessary to achieve self-realisation in this life as well as eternal salvation and liberation.

Does the Bhagavad Gita answer the youth as well?

Of course. The trials and tribulations of youth are not very different from those of adulthood: who am I? What do I believe in? What do I want out of life? What is my purpose here? Are these not questions that continue to plague us throughout our lives? Childhood and adolescence are simply times in which the intensity of the questions and the agony

caused by not knowing the answers are at their peak. Sure, the logistic concerns of youth differ from the logistic concerns of old age; however, at the core, we are all searching for truth, peace and happiness. The *Gita* provides this. Additionally, because it was sung by Lord Krishna Himself, the *Gita* has the miraculous ability to give the reader the exact answer and meaning he/she searches for. So, if we open it today in the midst of a crisis at work, we will come upon a passage that will speak something different to us than when we open it a year from now, looking for comfort after the death of a parent. Similarly, youth will find a different jewel in the treasure-chest than adults will. But, it is still a jewel from the ultimate treasure-chest.

In today's changing world, is there something in the Gita *for all of humanity?*

Definitely. This is what I have been saying. The truth is there for all to see. The sun does not disappear behind a cloud simply because a Christian or a Muslim stands under it. The *Gita* shows us the way to live with God, to live with each other and to live with Mother Earth in peace and harmony. This wisdom and insight is able to address the concerns of each generation, and yet stay as stable and everlasting as the peaks of the Himalayas.

Life Should be a Message

Each year on August 15, we celebrate India's Independence, and on January 30, we observe the anniversary of the assassination of Mahatma Gandhi. The former is an occasion for rejoicing, the latter an occasion for sombre reflection. We won our Independence, but we lost a beautiful soul, a true *maha atma* (great soul). As we revel in the joy of India's freedom, we must not forget the price we paid. Gandhi was truly the saint of the century and we pay our respects to him and pray that we never forget the message of his life.

As we reflect on the greatness of Mahatma Gandhi's life and the tragedy of his assassination, let us look not only at facts but also at their meanings. What was the meaning of his life? What was the message in his death? What does he have to teach the world of today?

We can answer these questions with the word *yagna*. *Yagna* was the spirit of his life and the message in his death. Every breath of his life, including the last, was an oblation to his country, his principles and his faith in God. The theme of his life was sacrifice.

Sacrifice for His Country

Mahatma Gandhi could have been a wealthy attorney. He could have led a life of relative ease and prosperity. But he was a man devoted to his country and to her freedom. Through his tireless efforts and simple piety, he led India to Independence. However, in spite of national and international acclaim, he never lost his humility, his dedication and his spirit of sacrifice. Rather, the flames of his true *yagna* to the nation seemed to only grow until he, himself, became the *poornahuti*, or final offering.

Typically in life, we always want to be the focus of everything. We always want the focus upon ourselves, the recognition for ourselves and the reward for ourselves. We do not actually work or accomplish anything meaningful, but we expend great effort trying to convince all those around us of our inestimable worth. However, Gandhi was different. He accomplished so much, yet he worked and lived with such humility and piety that he never put himself at the centre. This is a great message of his life: 'Work, serve with every breath, but remain a simple, humble, unattached child of God.'

There is a story of a man travelling by train to Porbandar in the same coach as Gandhiji. However, the man did not know that the old man in his coach was Mahatma Gandhi. So, all night long this man lay down on the seat, occupied the entire bench in the coach, pushed Gandhi, placed his feet on him, and left Gandhi barely enough room to sit upright. However, Gandhi did not fight or complain. How easy it would have been to proclaim, "I am Mahatma Gandhi. Give me room in the coach." But that is not the spirit of *yagna*.

As the train pulled into Porbandar, the man mentioned

that he was going to see the famous Mahatma Gandhi. Gandhiji still remained silent. As Gandhi descended from the train to a welcoming crowd of thousands, the man fell at his feet, begging for forgiveness. Gandhi, of course, blessed and forgave him, telling him only that he should be more respectful to others, regardless of who they are. This is the spirit of *yagna*. This is the spirit of India that we must maintain in our hearts.

Another beautiful example of Gandhi's humility, his selfless sacrifice for his country, is how he 'celebrated' his victory. When India won Independence and Gandhi became the hero of the country, he could have been in New Delhi receiving boundless honours and appreciation. But he was not in New Delhi, nor was he in Bombay, or in Calcutta. He was nowhere that would shower him with love and esteem. Rather, he was in East Bengal, where Hindus and Muslims were fighting bitterly. He was not content to have fulfilled his mission. If humans were still suffering, then he still had work to do. So, while the rest of the country celebrated, Gandhi continued his tireless work to heal the wounds between the Hindus and the Muslims. This was the spirit of his sacrifice. This is the spirit of divinity. Even when all external circumstances throw you to the centre, you remain humble, you remain simple, you remember for whom your *yagna* was performed. Gandhi's *yagna* was for his country, not for his own fame.

Sacrifice for Right Living

However, Gandhi's life was not only a sacrifice for Mother India, it was also a *yagna* of morality, of *dharma*, of ethics and

of truth. How easy it would have been to carry a gun to protect himself. Yet, the flames of Gandhi's *yagna* were fuelled by non-violence. Wars throughout history have been won with weapons. Gandhi was devoted to proving that peace could come only through peace. People criticised him vehemently for refusing to take up arms; they claimed he was forfeiting India's fight for freedom. Yet, he simply kept pouring truth, piety, and *dharma* into the fire of his life's *yagna* and the flames rose in victory. He sacrificed his popularity; he sacrificed his status as a fighter. Yet, truth prevailed and he is remembered as one of the greatest leaders — both political and spiritual — that the world has ever known.

Sacrifice to God

Mahatma Gandhi's life was dedicated in the service of God. His work for his country and his tenaciously held values were part and parcel of this complete sacrifice to the Divine. The *Gita* was his closest companion, and his most trusted guide.

So many people today claim that their lives and their work are God's. Yet, they use this as an excuse to lie, to cheat and even to kill. And at the end it is clear that they merely use God's name to serve themselves. Gandhi, on the other hand, was pure and his death is the clearest example. Due to his strong belief in *ahimsa* and true surrender to God, he refused to employ a bodyguard. Hence, he was gunned down on his way to a prayer meeting. As he drew his last breath, there was no sign of a fight, no break from his lifelong dedication to non-violence and to the Divine. He did not scream, 'Who are you? How dare you? Somebody help me!!'

Rather, the only words that escaped from his lips were, "*Hey Ram, Hey Ram, Hey Ram.*" That was the spirit of *yagna*.

So many people come and go in this world. So many people become famous through valiant efforts to make a name for themselves. Yet, how many of these people have really left lasting impressions or have really changed the course of history? Very few. When we depart from this earth, when we leave our bodies, what is it that remains? It is that which we have given to the world. It is that for which we have sacrificed. It is the love and the peace that our presence brought to those around us.

Gandhiji's name will live eternally not only because he brought Independence to India, but because of the *way* he brought peace and the message of his life.

When Gandhi was in South Africa, he was once travelling by train, and the conductor rudely told Gandhi to climb down. "But sir, I have a ticket," Gandhi replied.

The conductor violently threw him out of the train and yelled, "You do not deserve to ride on this train!" Gandhi, however, did not raise an arm in his defence. And today, does anyone know the name of the man who threw him from the train? Of course not. But, today the name of that train is the Mahatma Gandhi Train, and the name of the station is Mahatma Gandhi Station! That is the spirit of *yagna*.

Gandhi would have desired that his message lives on, his *yagna* continues to burn, bringing light and warmth to the world. In fact, when someone once asked him for a message, he replied, "My life is my message."

So, while we remember this *Mahatma*, let us live our lives as a sacrifice to world peace, as a sacrifice to our principles and as a sacrifice to God.

Drops of Nectar

Break all Bonds

Each year in August we celebrate the anniversary of India's Independence. We revel in memory of her non-violent victory over the British. Many historians have noted that India is the only country where people were colonised forcibly for many thousands of years, but the people lost neither the depth nor the richness of their ancient culture; nor did the people's loyalty to their culture wane or dissipate.

Yet, as we celebrate this glorious holiday, as we rejoice in our hard-earned freedom, let us look beyond our external freedom to rule independently. *Swarajya* means 'self-rule'; it means that we, the Indian people, have control over our own land, our own government and our own rules. So, we achieved outer *swarajya*; we achieved freedom from the British. But, have we achieved inner *swarajya*? Do we have control over ourselves? Are we truly free internally?

The fetters imposed by the British were overt and obvious. However, so many of us are still bound by fetters which are more subtle and insidious. They are the chains of our

attachments to worldly possessions; they are our cravings to be more and more Western, thereby leading us to forsake the richness of our culture; they are the fetters of corruption, both external and internal; they are our desires for sensual fulfilment.

Our attachments to worldly possessions and sensual pleasures keep us prisoners even more than the British imperial rule did. When our focus in life is on attaining more wealth, material objects, prestige, fame and comforts, then we must live within a set of rules even more restrictive than those imposed by the colonisers. We must forsake our family for our job. We must spend less and less time in spiritual pursuits in order to get ahead at work. We must travel extensively, thereby giving less and less time to the family. But most importantly, when we are focused on material success, or sensual pleasures, we are not even free in our own minds. We can check this by sitting quietly. What comes to the mind first? Is it God? Is it a passage from the scriptures? Is it a desire to go to a temple? No, when we are committed primarily to material prosperity, our predominant thoughts tend to be those pertaining to our career, investments, colleagues, projects and desires. These concerns trap us and prevent us from finding true freedom in life.

Yes, it is wonderful to be successful, prosperous, comfortable and to enjoy life. Even in our scriptures, Lord Krishna was a king who lived in a city of gold. However, it is the preoccupation with the accumulation of more and more of worldly objects that binds us. The obsession to succeed at all costs holds us captive. In order to be truly free, we must

loosen the fetters of attachment. We must perform our duties to God and not become slaves to our desires for possessions, because these can never be satiated; they can only lead to misery and bondage.

Another bond that enslaves many Indians today is the desire to be Western. The Western media — television, movies, commercials, magazines — have enraptured our youth who believe that the key to happiness lies in being Western. Thus, they chase Western fashion, Western entertainment and Western lifestyles. However, although the West has a great deal to offer in terms of academic and professional excellence, it does not hold the key to true peace and joy in life. The key lies in the ancient, yet timeless, culture of India. It lies in the wisdom of our scriptures and in our rich tradition. Thus, our youth have become victims of all that is Western. In their search for deep and lasting happiness, they find only superficial, temporary pleasure.

The key to breaking away these fetters lies in love and acceptance of India and her culture. It lies in learning — academically, professionally, technically and scientific-ally — from the West without abandoning our loyalty to our own value system and *sanskaras*. When our children look at themselves and say, 'I am proud to be Indian,' only then will they truly be free.

We are also bound by the fetters of corruption — corruption within our government and social systems, corruption within our families and ourselves. Corruption in the government and our social systems is a problem which must be eradicated if India is ever to be a truly free nation.

Freedom implies trust. Inherent in the meaning of true freedom is the ability to have faith in that system to which one adheres. If we require the people to pay heed to the government (and if we require them to abide by the rules set out by the government), then we must, in turn, give them a government in which they can have faith. Otherwise, if we demand their loyalty and obedience to a system riddled by corruption and dishonesty, then are we any better than a coloniser?

However, it is not only corruption in the government which enslaves the people; the corruption within our own hearts can be even more insidious. Are we honest? Are we righteous? Do we uphold the principles of *dharma*? We fought a long, arduous battle to win freedom. Let us truly bask in this freedom, realising the real richness of our values, ethics and *sanskaras*. The principles set forth in our scriptures are just as applicable to people living in modern Mumbai or Delhi as they were to people living thousands of years ago in the Himalayas. Let us break free from bonds of jealousy, anger and greed, as they bind not only our hands but also our hearts. Instead, let us live lives of generosity, *sewa*, love, purity and divinity, for then only will our hearts, minds and souls be free.

Teach with a Velvet Touch

Corporal punishment is all too frequently used in homes and schools across the world. Parents seem to believe that children require physical and emotional violence in order to be well-trained or to be properly scolded for their bad behaviour. This is, however, a tragic fallacy, leading to escalation of violence in our society.

Violence leads to violence. Peace leads to peace. This is a truth that pertains to countries at war as well as to children. When we raise our voices, become angry and aggressive, our children too raise their voices as their fragile bodies flood with anger and aggression. We hope that by becoming aggressive, our children will become calm, repentant and defensive. This is not the way the world works, however. When we act with anger, we create an environment of anger in the home. This negative energy persists, like a toxic chemical, in the home long after the actual fight is over. Our children at the most receptive time of life are then breathing in air filled with violence, lack of control and negativity. And we wonder why our world is becoming more violent each day. It is not such a mystery.

Additionally, when we hit our children, we also lose their respect. Children are much more perceptive and insightful than we sometimes believe. As they watch us turn red with rage and then explode in verbal or physical attacks, they know we have lost control. Their respect for us quickly diminishes. This, of course, pertains to teachers as well. It is so important for children to respect their teachers. How else can the young, exuberant bodies sit still for so many hours each day? Yet, when they lose respect for us as people, they simultaneously lose respect for what we are teaching. There are so many important lessons to be learned in school that we cannot let students lose their respect for teachers. We seem to believe that if we punish them severely they will respect us. This is absurd. Sure, they will fear us, but respect and fear are not even distantly related. We do not want the children's fear; we want their respect.

We complain that our children lie, that they hide things from us, that they disrespect us. We forget that children are like sponges who soak up every aspect of the environment in which they live. If they live with lies, they will tell lies. If they live with disrespect, they will show disrespect. If they live in the vicious cycle of action/reaction, they will only know how to act and react. If they live in a home in which there is neither tolerance nor understanding, they will learn to keep everything to themselves. However, if they live with patience, love and tolerance, they will manifest patience, love, tolerance as well as learn the lessons we teach them.

The key to having divine children lies in changing the nature of how we — as parents and teachers — behave. We

must never act in anger or frustration. We must wait until we have calmed down and then, gently and tenderly, explain things to children. Then, and only then, can we be sure they are getting the teaching they deserve, and not the brunt of our anger from the office or from the traffic on the way home. How many times have we had exasperating days and come home and vented it out on the children (or on our spouse who then, in turn, vents it out on the kids)? And what do children learn from this? Nothing other than low self-esteem and insufficiency in dealing with their own emotions.

So, the first thing to do is to wait until you are in a 'teaching' mood; not in a scolding mood. For children need not only the teaching, but they need the 'touch'. And that touch should be velvet; not violent. With a velvet touch and calm mind you can achieve anything with children. We should have visual communication. We should be able to simply look at them in a certain way and have them understand. There should never be the need to raise our voice.

Yet, I also understand that this is not easy. It is not easy to be calm when we are boiling with rage inside. It is not easy to use a velvet touch when our instinct is to hit.

Perhaps we say, 'But I was hit by my parents and by my teachers. That is just the way it should be.' Yet, we must be better than them. We must not fall into the trap of being like robots, unable to think critically. I, too, was slapped by my first spiritual master. He believed it to be the way to teach. Sure, at the time I obeyed him. I feared him. But I can see now that that was not the way to teach me. I can see, in retrospect, how much more I learned through his silence or

through his calm (and sometimes stern) words, than through his slaps.

Our scriptures say that a mother and father are enemies of their children unless they teach the children well, unless they fulfil their duties of imparting understanding and values. The scriptures say that these parents are enemies of their children unless they provide real education. Education does not mean simply dropping the children off at school each morning. It means ensuring that they are learning to differentiate right from wrong, truth from falsehood, integrity from deception.

This reminds me of a story I heard once. There was a man who was caught stealing. As this was part of a long string of burglaries, the judge finally sentenced the man to death. When the court asked the man what his last wish was, the man replied, "I want to meet my mother."

Thus, as the court always tries to fulfil the last wish of dying men, the mother was called. Upon her arrival, her son touched her feet and then, suddenly, leaped up and bit her face, causing blood to rush out of her gaping wounds. Everyone was astonished. Why would a dying man viciously maim his own mother?

In explanation, the man replied, "If I am going to die, it is because of her. All that I have become is because of her. When I was a small boy, I used to steal things. I would bring them to her and she would praise me. She never taught me that stealing was wrong; she simply encouraged it. And when she was angry with me, she never explained to me what I had done wrong. She never sat down with me to tenderly help me understand.

Instead, she would simply beat me or scream at me. In that way, I too learned violence instead of values. So, I wanted to show the world that if I have become a criminal worthy of death, it is because of my mother."

I do not tell this story so that we may all simply blame our parents for our own weaknesses. Rather, I tell it to illustrate the crucial nature of the effect parents and teachers have on children.

Children are the future of the planet called earth, and it is our responsibility to help them make that future a bright one. Will we lead the world towards violence or will we lead it towards love? Will we instil the values of forgiveness in the future world leaders, or will we instil the values of retribution and vengeance? Will we lead the world towards greater calm or towards greater chaos? We must never take for granted the role we play in the future of the world through what we teach our children.

Web of Life

The subject of biodiversity is a very ancient and complex topic which is addressed in the *Vedas* as part and parcel of India's cultural heritage. The entire realm of Nature is composed of five basic elements: *prithvi* (earth), *jal* (water), *vayu* (air), *agni* (fire) and *akash* (sky). According to our ancient traditions, these elements are revered, respected and worshipped as divine. As these forces are what give us life and sustain us, we must see them as divine.

Although these five forces can be separated and seen as discrete elements, the entire natural world is inextricably interwoven and interdependent. Nothing exists in a vacuum. The intricate ways in which one species affects another are hard to fathom. They say, for example, that by letting one species of frog from the Brazilian rain-forest become extinct, we are causing a cascade of events, that could potentially lead to the demise of the human race. It is not the frog itself that is so crucial to our existence. Rather, it is the web of life that connects us all. We cannot destroy Mother

Earth and yet convince ourselves that we have a bright future ahead of us.

A wise man once said:

"All things are connected. This we know. The earth does not belong to man; man belongs to the earth. All things are connected, like the blood which unites our family. Whatever befalls the earth, befalls the sons of the earth. Man did not weave the web of life; he is merely a strand in it. Whatever he does to the web, he does to himself."

Yet, in the face of this, we allow (and cause) thousands of species of plants and animals to become extinct each year due to our disrespectful and indiscriminate behaviour towards Mother Earth. In addition to providing food, wood for our homes, and the simple beauty of Nature, more than 25 per cent of the world's medicines come from our forests. We would not set fire to our own homes. We would not destroy our supermarket or pharmacy. Why can we not show the same respect to our real home, our real supermarket, our real pharmacy? We must have more respect for this land which gives us life, nourishes us, protects us, heals us and sustains us.

India is a land rich in natural resources, rich in lush, untouched beauty, and rich in its ability to provide food, water and land to its people. Methods of agriculture and farming must be in concert with the natural laws of the land. When we try to impose our own demands on land, we limit its inherent ability to produce fruitfully and with variety.

The US Agricultural Service has converted American

forests, woods and fertile areas to grazing land for the cattle that later become hamburgers.

More than 260 million acres of American forests have been turned into grazing land for the beef-laden diets of its inhabitants. Since 1967, one acre of forest has been destroyed every five seconds. If the present trend continues, the country that was seen as the 'land of plenty' will be completely stripped bare of all its forests in just a few decades!

Yet this tragedy far exceeds the loss of aesthetic, natural beauty. As our forests are destroyed, more and more species become extinct, our water becomes less and less drinkable, the air becomes polluted and thus we pull apart the web of life, strand by strand. Gradually the strong, tightly woven web becomes fragile, fighting to hold itself together.

A proverb says, *'The frog does not drink up the pond in which he lives.'* We too must follow the example of the frog and preserve the gifts of Nature bestowed on us by God.

A man once lived a long and pious life. When he died, God took his hand and said, "Come, I will show you hell."

And the Lord took the man to a room where many people sat around a pot filled with food. The pot was deep, so a long spoon was needed. Each person held a spoon, but the spoon was so long that the people could not feed themselves. Their suffering was unbelievable. The people were famished and weak.

Next, the Lord said, "Come, I will show you heaven."

He then took the man to a room that was identical to the first: many people sitting around a large pot of luscious

food. Here the pot was just as deep, the spoons were just as long, but the people were joyous and healthy.

"I don't understand it," the man said. "Everything is the same as in hell, but here all the people are so content and well fed."

"The difference between heaven and hell," God said, "is that in heaven people have learned to feed each other."

Let us realise that left to ourselves we would suffer and starve. We depend upon each other — humans, animals, plants, water — to survive. Let us continually remind ourselves of the ocean in which we are only drops. Let us not turn a blind eye to the web Mother Earth has so gently woven around us.

Remove Artificial Barriers:
Questions and Answers

The Hindu religion is losing its direction by remaining grossly divided in terms of castes and sub-castes. What, according to you, would be the way to bring about unity under one umbrella?

The caste system as we see it today was originally simply a division of labour based on personal talents, tendencies and abilities. It was never supposed to divide people. Rather, it was supposed to unite people so that everyone would work to the best of his/her ability for the greater service of all. In the scriptures, when the system of dividing society into four groups was explained, the word used was *varna*. *Varna* means 'class', not 'caste'. Caste is actually *jati* and it is an incorrect translation of the word *varna*. When the Portuguese colonised parts of India, they mistakenly translated *varna vyavasthaa* as 'caste system' and the mistake has stayed since then.

The *varna* system was based on a person's characteristics, temperament and innate nature. The *Vedas* describe one's nature as being a mixture of the three *gunas* — *tamas, rajas*

and *sattva*. Depending on the relative proportions of each of these *gunas*, one is classified as a Brahmin, Kshatriya, Vaishya or Shudra. For example, Brahmins, who perform the intellectual, creative and spiritual work within the community, have a high proportion of *sattva* and low proportions of *tamas* and *rajas*. A Kshatriya, who is inclined toward political, administrative and military work, has a high proportion of *rajas*, a medium proportion of *sattva* and a low proportion of *tamas*. A Vaishya, who performs the tasks of businessman, employer and skilled labourer, has a high proportion of *rajas* but has relatively equal proportions of *sattva* and *tamas*, both of which are lower than *rajas*. Lastly, a Shudra, who performs unskilled labour in society, has a high proportion of *tamas*, a low proportion of *sattva* and a medium proportion of *rajas*.

These *gunas* are not inherited. They are based on one's inherent nature and *karma*. Therefore one's *varna* was not supposed to be based on heredity, and in the past it was not. It is only in relatively modern times that the strict, rigid, heredity-based caste system has come into existence. There are many examples in the scriptures and in history of people transcending the class or *varna* into which they were born. Everyone was free to choose an occupation according to his/ her *guna* and *karma*.

Furthermore, according to the scriptures, there is no hierarchy inherent in the *varna* system. All are equal in importance and equal in worth. A good example is to imagine a human body. The brain which thinks, plans and guides represents the Brahmin caste. The hands and arms which fight, protect and work represent the Kshatriya caste. The

stomach which serves as the source of energy represents the Vaishya caste, and the legs that do the necessary running around in the service of the rest of the body represent the Shudra caste. No one can say the brain is better than the legs or that hands are superior to feet. Each is equally important for the overall functioning of the body. The only difference is that they serve different roles.

The way to unite people now is education. We must bring awareness that all people are equal and that there are no small or big or superior or inferior persons. Spiritual leaders and other teachers can teach the truth of the scriptures and help eradicate this prejudice.

Look at Lord Rama and Lord Krishna. Both set an example in taking food from the people of the lowest caste and visiting their homes. It is devotion, purity and commitment which make us great or small, not our caste.

Many Indians living abroad, even today, restrict themselves within one's own caste and community whenever it comes to organising their children's marriages. Is this a proper procedure to continue these days? Should these practices be liberalised?

These regulations should be opposed. Parents' focus should be on encouraging their children to marry Indians rather than being confined to a particular caste. The important thing is that our children marry Indians so that the culture and traditions are passed on. Ideally a Gujarati must marry a Gujarati, a Punjabi marry a Punjabi because then the tradition, language, culture, etc. will be familiar and similar. It is easier to travel along the path of life if the partner shares a similar

background, language, culture and tradition. However, this is not mandatory. Parents should be flexible about marriage partners as long as they are within the same community.

This tendency should be inculcated in our children from a very young age. We should infuse our culture, traditions, rituals and heritage in them so that they automatically marry someone who shares a similar culture.

Caste-based social organisations are often formed by Indians living in foreign countries. Do you think this is a welcome trend in the 21st century? Should such organisations be allowed to continue? Should these be replaced by other alternatives? If so, how?

We should overcome such beliefs. They are outdated. If living abroad, Hindus should focus on being Hindus rather than being a part of their particular caste. Being Indian should be our identity when living abroad. In that way we can be united.

Organisations can certainly exist within the Hindu community, but they should be based on language and culture rather than on caste. So, for example, there is the Gujarati Samaj or the Punjabi Association, etc.

Caste system was at the root of the differences in the social levels among Hindus as individuals. Many social reformers struggled during their lifetime to rid society of the evils of the caste system. And yet, these evils persist even today. What do you think could be done to eradicate this evil?

Yes, the problems exist, but change is there. People are changing. However, more has to be done. We must keep working to eradicate this problem.

One of the reasons that it has not yet been eradicated within India is that politicians have used the caste divisions for their own sake. But this must stop. The time has come for everyone to realise that it is weakening the community.

"What caste do you belong to?" is the first question many Indians believing in the caste system ask whenever they meet one another! Would you consider this question appropriate in these days?

This is not a good question at all. Originally, as I mentioned, caste was just a division of labour, a division of jobs. So, really it would be more in keeping with the true meaning of 'caste' if we ask each other, 'What is your job?'

Nowadays caste has no bearing on the job. Brahmins, who are supposed to be teachers and priests, are running shoe companies. Vaishyas are taking care of temples and are teachers. Kshatriyas rarely serve as soldiers. Everyone is doing everyone else's job now. So, the question has no connection to its original meaning and is only a way of judging others and putting them into a slot of 'superior' or 'inferior'. Therefore, it should not be used. These prejudices are simply harming our society.

A good rebuttal is simply to say, "I am an Indian," or, "I am a Hindu," or, "I am Gujarati," or, "I am a child of God." Or, if you really want to answer the question in its true meaning, then you can say, "I am a businessman," or, "I am a teacher," or, "I am a doctor."

At the government level also, we have not been able to do away with class differences like Savarnas and Scheduled/ Backward Classes. These have continued to offer protection

under the 'system of reservations' in the areas of education and employment. What is your opinion on this subject?

The system of reservation and the special protection services should remain but they should be based on need, not on caste. They should be based on poverty levels and socio-economic status, not on caste. Anyone, no matter to which caste he belongs, if he lives below a certain standard, should be helped.

Do you think a day will dawn when all Hindus would unitedly say: "We are all one and united"? What should be done by social, political and religious reformers in order to achieve this?

Yes. I am very positive and optimistic. I do think that the day will come when we will all be united. Lord Rama built bridges between men and men, animals and men, animals and animals. He even built bridges to the demons! We should take this example and communities should start building bridges between different castes and different communities.

Our problem is our ego, which comes in the way of our unity. Look at the 'I'. Wherever it is, it always stands capital — whether at the beginning of a sentence, the middle of a sentence or the end of a sentence. 'I' represents our ego. This capital 'I' is a border, a boundary, a wall between us. Our egos stand in the way of our unity. Whether it is our personal egos, or egos about the superiority of our particular caste or society, the key is to bend our egos. We must bend the 'I' and turn it from vertical to horizontal. When the 'I' becomes horizontal, then it serves as a bridge between people, families, communities and nations.

Pariksha, Samiksha and Pratiksha

A spiritual path has three important components: *pariksha* (tests), *samiksha* (introspection) and *pratiksha* (wait).

True *pariksha* is not simply in passing a test given by someone else. True *pariksha* is when we start taking our own test, i.e. when we take our own picture with the camera of our heart, when we start checking ourself all the time — checking our actions, thoughts, eyes and ears. We must not simply rely on others to test us in life. Sometimes we can fool others, but we can never fool God and we can never fool our guru. So, the true *pariksha* is when we start watching ourself, knowing that God and guru are always watching us.

There is a beautiful story of a guru who, nearing the end of his inhabitance in this earthly body, called his three closest disciples together and said, "I'm giving you a test. To each of you I will give an apple. You must go from here, eat the apple without being seen by anyone and then return as quickly as possible. He who returns first will be my successor. But, be sure that no one sees you."

The three disciples were each given their apple and they went off in three separate directions. After a few hours the first disciple returned, "Guruji," he exclaimed, "I went to the top of the highest mountain and there I ate my apple. Even the birds could not fly as high as this mountain; therefore, there was nobody who could see me." The guru nodded in silence.

In the evening the second disciple returned, breathless. "Guruji, Guruji, I went into the deepest, darkest cave in the mountainside. There I crawled into the darkness and ate my apple, unseen by any being." The guru nodded but said nothing.

The night passed as did the following day, but still the third disciple did not return. Finally, on the afternoon of the fourth day, the disciple returned slowly with his head down. "I have failed you, my master," he said. "I climbed mountains, I swam rivers, I crawled into the trunks of trees and into deep pits in the ground. But everywhere I went, God's eyes were watching me. There was nowhere I could escape His gaze."

The Master replied, "You, my child, are the one who shall be my successor, for you are the only one who understands the true nature of God and His omniscience."

When we realise that God is always watching us, then we will never go astray. That is true *pariksha*.

The second aspect is *samiksha* — introspection. We must constantly analyse and re-analyse ourselves. At the end of the day, a good businessman always checks his balance sheet: how much did he make, how much did he spend. Similarly, a good teacher reviews her students' test scores thus: how many passed, how many failed.

By looking at their successes and failures, they assess how well they are doing. Are the businessman's profits greater than his losses? Are most of the teacher's students passing the exams?

In the same way, each night, we must examine the balance sheet of our day: what were our successes, what were our failures. And for all the successes, all our 'plus points', we must give credit to God. For, we have truly done nothing but let Him work through us. All credit goes to Him. He is the one who saves us, who maintains our dignity and our success. It is only by His grace that our eyes can see the work in front of us, that our hands can perform the necessary tasks, that our brains can understand instructions, that our mouths can speak. So, we must never become arrogant; we must never think that it is we who have accomplished something. It is only His grace working through us.

Our failures, we must also give to him. The fault is ours, definitely. Yet, He is so forgiving and so compassionate that He insists we turn these over to Him as well. We must say, 'God, please take these minus points. You know that I am weak, you know that I am nothing. Please make me stronger tomorrow.' In this way, each night we check our balance sheet and we pray to God to help us have fewer minus points, to make us stronger, to make us a better hand at work, to give us more faith, more devotion.

A true spiritual seeker introspects frequently and always strives to be a better person the next day.

Last is *pratiksha* — patience. One must always wait. We must perform our *sadhana*, our duties and then wait for the

grace of God to shine upon us. Sometimes I hear people say, "But when will He bless me with a vision of Him?" Or, "I have been doing *sadhana* for so long and still my mind is restless." There is no fixed rule for how quickly one can attain a state of spiritual bliss. His grace and blessings will be bestowed upon those who dedicate their lives to Him. This is certain. Only the time and way are in His hands, so, we must just keep doing our *sadhana*, keep surrendering to Him, stay humble and pure. We must have faith that at the right time His shower of grace will fall upon us.

Stories to Teach Our Mind, Touch Our Heart and Uplift Our Spirit

Danger of Anger

A young boy had a foul temper. He used to speak harshly and get angry many times a day, at the slightest provocation. His wise father told him that every time he got angry he had to hammer a nail into a wooden fence in the backyard. The first day the boy hammered 45 nails into the fence — practically his entire day was spent in the backyard. The next day, with his arm sore from hammering, he tried to get less angry. He hammered only 25 nails into the fence the second day. By the end of a few weeks, the boy proudly went to his father and told him that he had not become angry that day.

So, the boy's father told him that now he could start removing the nails from the fence. There were two ways that nails could be removed: either the boy could go an entire day without getting mad, or the boy could apologise sincerely to someone whom he had hurt through his anger.

So, the boy began to apologise to people whom he had wounded and he tried hard not to get angry. Slowly, the nails began to get pulled out of the fence. One day, the boy proudly went to his father and told him that all the nails were out of the fence and that anger was "a thing of the past".

His father then led the boy by the hand to the fence and showed him how the fence was now riddled with holes. It was no longer the sturdy, strong fence it once had been. It was now weakened and damaged. Every time the wind blew strongly, the fence swayed in the wind, for it was so full of holes that the breeze caused the fence to shake.

"Do you see that?" the father asked the boy. "For you, anger is a thing of the past. Yet, this fence will never recover. Every time you get angry at someone, it is like driving a nail into them. You may later remove the nail, but the hole is still there. The effect of your anger cannot be removed."

In life sometimes it is easy to get angry, easy to yell, easy to hit those we love. We assuage our own conscience by saying, 'He made me mad,' or 'She made me hit her'. But, whose hand is it really that hits? Whose mouth is it really that speaks harsh words?

We think, 'It's no big deal. I said sorry,' or we say, 'Oh, but that was yesterday. Today I've been nice.' For us, it may be that easy. But remember the fence is riddled with holes, even though you have moved on. If you hammer enough nails into someone, eventually they will be forever weakened, forever damaged. You can stab someone with a knife and then pull out the knife but the blood will continue to flow out. 'Sorry' does not stop the blood. It may pave the way to recovery, but the wound is still there.

The goal in life should be to be like water — a stone falls in it and only causes a ripple for a moment. The 'hole' in the water caused by a large boulder does not last for more than a few seconds. When we get hit — verbally, physically or

emotionally — we should be like the water. We should be able to just let the ripples flow and, within a few moments, it should look as though nothing ever happened.

However, unfortunately, it is very difficult to be like the water. Very few people in the world are able to accomplish this task, for it is a task of great *sadhana* and *vairagya* (non-attachment). Children are like the wooden fence. No matter how much they grow in life, no matter how wise they become or how old and strong they become, those holes are still there.

We must remember that our loved ones are like wood. Therefore, we must try to be very, very careful before we hammer holes into anyone, for if there are too many holes, the fence will fall.

Service to Others

A disciple of Lord Buddha wanted to publish a book on the teachings of Buddhism. So, he spent several years compiling the great wisdom of Lord Buddha. Then, it was time for the task of raising enough money to publish the book. He went door-to-door to his friends and neighbours requesting for help in bringing this project to fruition.

On collecting enough funds, he went to publish the book, when a cyclone hit a backward area of the country. Immediately, he sent all the funds to the disaster-struck region to help the victims.

Again, he underwent the task of collecting money to publish this book. Again, his friends, relatives and colleagues helped him reach the goal. Then an earthquake struck another part of the country, killing thousands. Again, the disciple sent all of his hard-earned funds to the region.

Several years passed during which he tried, with difficulty, to raise the funds a third time. However, people were not ready to give for the same book. Thus, it took him quite some

time to raise enough money to publish the book. No catastrophe struck and the book was published. On the inside cover of the book, beneath the title *Teachings of Lord Buddha* was written 'Third Edition'.

So many times in life we read spiritual teachings, we listen to lectures and *katha*, we say our prayers. However, do we actually implement these teachings in our life? The book was a 'third edition' because the teachings of Buddhism include compassion, non-attachment and service to the poor. Thus, by donating the funds meant for the book to disaster-struck victims, the disciple was actually teaching and illustrating the word of the Buddha.

He knew that the word of the Buddha was to help those in need. Thus, it is even more illustrative of Buddhism to help the poor than to publish a book.

In our lives, too, we must remember not only the words of the teachings, but also the true message of the teachings. We read books, we listen to lectures, but do we absorb the message? Sometimes we get so caught up in reading, hearing and reciting these teachings that we forget to live them! Service to others is the true message, the true teaching, the true wisdom of spirituality.

Face Challenges Stoically

There was once a man who noticed a beautifully woven cocoon on a tree outside his home. He carefully watched the cocoon every day in order to catch the first glimpse of the beautiful butterfly he knew would emerge. Finally, one day he saw a tiny hole in the cocoon which grew quickly as the hours passed. He sat watching the butterfly break her way out of the cocoon. However, suddenly he noticed that it seemed the butterfly had stopped making progress. The hole did not get any larger and the butterfly seemed to be stuck. The cocoon was bouncing up and down on the branch as the butterfly tried to squeeze herself, unsuccessfully, through the hole she had created.

The man watched in dismay as it seemed the butterfly would not be able to emerge. Finally, he went inside, took a small pair of scissors, and carefully cut the cocoon, allowing the butterfly to emerge easily. However, the butterfly immediately dropped to the ground instead of soaring gracefully into the sky as he had imagined she would.

The man noticed that the butterfly's stomach was swollen and distended but her wings were small and shrivelled, explaining her inability to fly. He assumed that after some time, the stomach would shrink and the wings would expand, and she would fly in her fullest glory. However, this was never to be.

The man didn't know that it was the very act of forcing her body through the tiny hole in the cocoon which would push all the fluid from her stomach into her wings. Without that external pressure, the stomach would always be swollen and the wings would always be shrivelled.

In life too, we frequently avoid challenges, looking for the easy way out. We look for people who will 'cut our cocoons', so that we never have to work and push our way through anything. However, little do we realise that it is going through those times of difficulty which prepare us for the road ahead. The obstacles in our path are God's way of enabling us to fly. With every bit of pushing and struggling, our wings become fuller.

Frequently, people come to me and say, "Oh, why has God given me so much strife? Why has He put so many obstacles in my path? Why is He punishing me?" We must realise these are not punishments. Sure, *karma* plays a large role in what we receive in this lifetime, but even the things that seem like 'bad' *karma*, are actually opportunities for growth. Even an extra small hole to squeeze through is actually an opportunity for our wings to expand to great lengths.

So, let us learn to take our challenges for what they are, rather than looking around for a different hole, or for someone with a pair of scissors.

Lip Service is not Enough

A small, impoverished boy was standing barefeet on the New York city streets, looking wistfully at the window of a shoe store. A well-dressed woman saw him and asked him, "Why are you looking so solemnly at this window?"

The small boy looked up at her and replied, "I am asking God to give me a pair of shoes."

The woman took the boy's hand and led him into the shoe store, where she immediately asked the clerk for a bucket of warm water and 10 pairs of socks. Then, placing the boy's dirty feet into the water, she tenderly washed them and then put a pair of warm socks on him. Then, she told the clerk to bring shoes for the boy.

As they left the store with the boy's small feet now snugly in a pair of new shoes, he clenched the woman's hand and looked up into her eyes. "Are you God's wife?" he asked.

This story is not only a beautiful snippet from life in a big city, it is a deep lesson about how to live our own lives. Instead of simply saying, "Oh, how sweet," and moving on, let us really take this story to heart.

How easy it is to pass by those less fortunate with a simple sigh of sympathy or with a token 'aid', perhaps a coin or two tossed in their direction. These small gestures of empathy and charity make us feel like we are compassionate people who just live in an unjust world. However, is the homeless man helped by our sigh of disdain? Does the coin we hand him really make a difference? Are we really being compassionate, or are we just soothing our own conscience?

How much more difficult it is to really stop, take a moment out of our hectic lives and see what is needed. Yet, how much more divine that is. There are always places to be and things to do. If we wait until we are free in order to take care of others, the time will never come. Real divinity, real selflessness is in giving when it is not necessarily convenient to give. It is in giving according to others' needs, not according to our own agenda and convenience.

The wealthy woman probably had some place to go to on that cold day in New York city. She could have easily walked past the boy, thinking to herself, 'Our government really needs to do something about homelessness' or she could have looked the other way and continued with her errand. But she didn't. That is what makes her special.

We shower each other with new clothes, toys and other merchandise on birthdays and anniversaries. No problem. We love each other and so we give gifts. However, let us also remember to extend that compassion and that love to others who really need it. Let us vow never to turn a blind eye to someone in need. Let us vow to use what God has given us to really serve His children. Let us live our lives as though we, too, are 'God's wife'.

Do Not Kill the Golden Goose

There was once a very great *sanyasi* who possessed the ability to transform people by his mere words. The sound of his voice carried listeners into the most peaceful meditation. But he wanted to do more for the world. His vision was to help all of humanity, to be of service to all those he met, to heal the world on a massive scale.

He prayed to God to give him the ability to save people's lives. "You cannot save everyone; you cannot be of service to everyone. Just keep speaking, keep chanting, keep writing, keep praying. In this way you will really heal," said God to him.

But the saint was not persuaded. "Please, God, let me be of service — of direct service — to all. Let me save people's lives."

The *sanyasi* had performed so much *tapasya* and was so pure in his desire to help that God granted him the boon of being able to save the life of anyone who came to him. He had simply to take a drop of his blood and place it on the patient's upper lip. Any ailment could be cured; any suffering

could immediately be alleviated. The saint was exuberant; his dream had been fulfilled. Now he felt that he would really be able to save the world and cure those who came to him.

The first day four people came. For each person, he simply pricked the tip of his finger with a needle and the blood oozed out. One small drop had miraculous healing powers. That night, the selfless saint had a beaming smile on his face for those whom he had cured.

The next day, forty people came, having heard of his miraculous powers. For each he squeezed a small drop of blood from his finger and blessed them as he placed it on their upper lip. Each was instantly cured. Paralysis, leprosy, depression, anxiety — all disappeared with a drop of the *sanyasi's* blood. As word spread throughout the land, more and more people flocked to his healing magic. And the *sanyasi* was in bliss — here he was using his simple God-given blood to cure so many. He dispensed these drops freely — with no hesitation, no dis-crimination, no vacation. "I am in your service..." he would say.

Soon, thousands were flooding to the simple *ashram* in which he lived; they were overflowing on to the streets. The saint was dispensing the equivalent of cups of blood each day. But, he did not even notice. Such was his dedication and devotion to those whom he was curing. He sat in meditative bliss, as he squeezed first his fingertip, then the veins in his arm to dispense blood to those in need.

It was not long before the *sanyasi* had to squeeze harder in order to coax the blood from his body. Soon, a mere needle prick was not a large enough opening; he needed small knives

to pierce the prominent veins of his forearms and legs. From there, the blood flowed freely again, and all were relieved. However, soon, even those veins were no longer coursing with high volumes of the healing nectar. They, too, were becoming drier and drier.

As his blood volume dropped each day, the *sanyasi* became weaker. The colour drained from his once vibrant face. Darkness drew circles around his eyes. His voice, which previously had boomed, singing forth the divine glories of God, was now not much more than a whisper. But, the *sanyasi* was not worried. Those who loved him urged him to take rest, to take at least a break from giving blood, to let himself recuperate.

Although he listened with his ears and appreciated the concern, he could not stop pumping blood from his body. He would say, 'I am in the service of the world...These people have come from so far...They have been waiting for so long...This man is an important minister, but he's suffering from pneumonia...I feel no pain. I feel no weakness. I feel only the joy of giving myself to others.' Those who loved him could do nothing, other than watch the scores of people continue to pour in, continue to plead for "just one drop".

Soon, even the once succulent veins of his forearms would give no more blood. Even the largest, most abundant veins of his body held on selfishly to their sparse quantity of this life-giving fluid. But, the *sanyasi* was not deterred. "This is only a challenge. Only more *tapasya* to do," he said. He ordered his servants to build a device which would squeeze harder than human hands were able to; a vice-like apparatus into which he could place a limb and have it milked completely of the blood inside.

Throughout this, the people kept coming. As word spread — in frantic whispers — that the saint was ill, that the blood was running dry, the people flocked even more frenetically. They pushed and trampled upon one another in an effort to get "just one drop". The people, who perhaps had been postponing a visit until a later date, dropped everything and came running. "Please *Maharajji*," they pleaded. "Please, just one drop. We have come from Madras, we have come from Nepal, we have come from London. My daughter has this horrible affliction on her face. My husband lost his arm in a car wreck. My son refuses to get married. Please *Maharajji*, please just one drop. Just one drop and then we'll go away so you can take rest." For each one who came, the saint smiled as he placed a drop of blood on their upper lip.

The ocean of his blood soon became an arid desert. Where once his veins had flowed like copious rivers, they were now limp and desiccated.

His devotees pleaded with him to stop, their tears of concern poured onto his holy feet. But, all he could see were the needy, ailing people stretching out to the horizon, each one crying pitifully, "Please, *Maharajji*, just one drop."

When those who had flocked for blood realised that the *sanyasi* could give no more, they were undeterred. "We will work the pumping machine," they screamed. And they stormed towards the saint, who sat peacefully, although nearly lifeless, draped only in his simple *dhoti*. But the pumping machine was not powerful enough to pump water from a desert. So, they tied him up, the ropes cutting deep into his parched skin. And as some pulled the ropes tighter and tighter, others cut

into his veins with knives (no longer small ones, but the type used for butchering animals). "There must be another drop left. There must be," they cried furiously.

As his beloved devotees watched, the last drop of life-blood was squeezed out from their great *sanyasi*, who had once overflowed with life, with vigour, with dynamism. Now he hung, lifeless, still in the ropes which had tied him, completely desiccated. However, they noticed, there was a smile on his limp and pallid face.

"Just five minutes," we plead. "Just step in my house to bless it…just take one meal at my home." It may not be physical blood we demand, but both our desperation and the effects on the saints are the same. "But, I've waited five years. But I've come from America. Please, *Maharajji*, just five minutes…but *Maharajji*, my daughter said she won't get married unless you are there… "

When we go to visit a saint, rarely do we ask when he last took his meal or what his usual time for rest is. 'It's only five minutes,' we convince ourselves. 'Just one drop, one drop of blood…' When we are blessed enough to have a saint at our home, rarely do we say to him, 'Go to sleep. You must be tired. You have sat with people [or worked] all day long.' Rather, we think, 'But, it's only once a year he comes,' or, 'but this is the first time we've ever had him alone.'

"Just one drop… just one drop and then we'll let you take rest."

Sure, it is only five minutes, or one hour, or one night. For us. But, we do not have the vision to see the streams of people, flooding out to the horizon, who will beg for "just five minutes",

after we have had ours. Rarely ever do we lift our eyes to look.

'But,' you may ask, 'if the saint healed so many with his blood, why does it matter that he died? His purpose on earth and his desire were to heal people. So, why does it matter that he lost his physical body in the process?'

The answer is that a doctor could have healed most of the physical ailments that came to him. Those suffering from emotional/psychological problems could probably have been helped had they put into practice that which he taught in his lectures. He did not need to give his actual blood to so many. But, it is easier to get the instant cure, easier to let him place the blood up on us than to make the trip to the doctor and take the medicine he prescribes, or to implement the necessary diet of less fat, less sugar, no meat, etc.

It is easier to be cured by someone than to cure ourselves. Somehow, when a saint speaks in public, giving instructions and messages publicly, we think that it pertains to everyone but us. 'But I need to speak to him personally,' we decide. 'My problem is different.' Rarely do we take a saint's 'no' as a 'no'. We know that if we plead harder, beg more desperately, then they will give in, because they truly are in the service of humanity.

But, do we want to milk the blood from their bodies? Do we really want to be healed at their expense? Is that what love really is? We must realise that each of our demands, that every five minutes, each compulsory visit to a home, each one drop of blood, is only one of the thousands more that he is selflessly giving to others. We must be careful to let him nourish himself such that his blood continues to flow. We must make a sincere effort to keep alive the saint who would give his life to us, without hesitation and without discrimination.

Face Obstacles with Courage

One day in an ancient village, the villagers found a large boulder in the middle of their main pathway. The busy, rich businessmen and merchants had their servants carry them around it. Others simply turned back and returned in the direction from which they'd come, realising that to try to pass it was futile. Still others gathered around the site of the boulder to criticise the king of the area for not taking better care of the roads. They stood by as the boulder obstructed the passage on the road, condemning the king and his ministers for their laziness!

Finally, a peasant came by who was carrying a load of vegetables to sell in the market. He needed to pass the boulder and so he calmly put down his heavy load and tried to push the boulder out of the way. However, the boulder was quite heavy. The peasant kept pushing from different angles and finally the boulder rolled away from the road. As he bent down to pick up his load of vegetables, the peasant noticed something lying on the road where the boulder had been. It was a wallet filled with gold coins and a note from the king.

The note said, 'This reward is for one who has the commitment to move the boulder from the road.'

Frequently in life, we see that the 'king' has thrown obstacles in our path. Our natural instinct is to bypass them, using our influence or wealth, or to simply turn around and go down a different path. Or, we give up the path altogether, seeing the obstacles as insurmountable. Perhaps we find ourselves criticising life, circumstances, or the great 'king' who is making our life difficult. Yet, for he who has the commitment and dedication to conquer the obstacle, the rewards are great. Not only will the path be clear, but we will also become far richer (be it spiritually, mentally or financially) by having the tenacity to overcome the hurdles in our path.

Life is not always a clear path. If it were, we would learn very little. Rather, to test us, to teach us, to mould us and to make us stronger, God challenges us. He, as the king of kings, places obstacles on our way. And, just like the king in the above story, He watches to see who will have the courage and the commitment to overcome these difficulties.

There is a beautiful saying in our scriptures:

Prarabhyate na khalu vighna bhayena nicheh

prarabhya vighna vihata virmanti madhyah

vighneh punah punarapi prati-hanya manah

prarabhya chottam-janah na parityajanti.

This means that there are three types of people in the world. The first type, the lowest on the hierarchy of evolution towards realising God, contemplate the possibilities of failure before undertaking any task. Then, realising that some obstacle

will inevitably arise, and fearing the difficulties inherent in overcoming the obstacle, they decide not to act. Thus their lives pass in vain, and they perform no good deeds at all, for they are paralysed by thoughts of hurdles that may arise.

The second type of people begin to perform good deeds but as soon as they encounter any difficulty, they turn back and relinquish the task. These people have good hearts and good intentions and they want to perform worthwhile deeds; however, they are unable to gather up the inner resources necessary to overcome the challenges. Thus, their lives also pass in vain, and although they have innumerable projects that were well begun, they have not even one that was completed.

The third, and the greatest, type of people are those who just keep going, no matter what obstacles they find in their path. They are so committed to completing their duties successfully that they steadfastly remove all hurdles from their way. They are entirely focused and centred on the ultimate goal, and they keep God's image in their mind, knowing that He is with them and that He will help them achieve their noble goals. These are the people who succeed, not only professionally in life, but also spiritually and mentally.

Divine Assistance

There was once a man who was a great devotee of God. He always believed that God would take care of him, regardless of the circumstances.

One day a great flood struck the town in which he lived. All the neighbours began evacuating their homes. However, this man was not worried. 'God will take care of me,' he assured himself.

Soon, the flood waters began to rise and water filled the first floor of the man's home. 'No problem,' he thought and moved to the second floor. At this time a boat came by, and the men in the boat shouted to him through the window, "Climb in, we'll save you."

"No," the man replied calmly. "That's all right. God will save me."

The men in the boat urged him to evacuate his home. "The waters are rising," they cried. But the man was undisturbed and sent them away, firm in his conviction that God would come to his help.

However, the rain continued and the waters rose. The second and then the third floor of his house filled with water. 'No problem,' he thought as he moved onto his rooftop. Sitting on the rooftop, wrapped in a rain-coat, the man saw a helicopter fly overhead. From the helicopter, a life-preserver dropped down into the man's lap. "Grab on," the pilot yelled, "I'll save you."

But, the man would not grab on. "God will save me," he yelled back. "I don't need your life-preserver." Eventually, the helicopter flew away.

The flood rose and soon the man drowned.

When he entered heaven, he said to God, "What happened? How could you let me drown? I thought you said you'd always save me. I had such faith in you."

God looked at the man sadly and said, "I sent you a boat; I sent you a helicopter. What more could I do?"

How many times in life do we avoid taking advantage of the situations which present themselves, instead holding tenaciously to our belief in *karma*, or fate, or divine will/intervention? God will not always come to us draped in a saffron *dhoti*, flute in hand and whisk us away from unfortunate situations in His chariot. He is more subtle, less obvious. He sends us the life-preserver, but it is our choice whether to recognise it and grab on, or to cling to the belief that something better and easier will come along shortly.

Karma does not mean that we have no choice or no free will. It means we are handed a certain set of circumstances due to our past lives, *sanskaras* and so many other factors.

However, what we do with that set of circumstances is only partly determined by fate; the rest is determined by our own free will. For example, let's say that due to past *karma*, in this birth we are given a cow. The cow is due to our past *karma* and our fate. We cannot change it and get a goat or a dog instead. But, what we do with the cow is up to us. If we drink its milk and use its manure in our fields, then we will have radiant health and rich, fertile crops. However, if we eat the manure and spill the milk on the ground, our health will suffer and our crops will be weak and unproductive.

So many times we blame God for the situations in our lives, or we simply concede that it 'must be our *karma*'. Yet, sickness and failing crops are not our *karma*; rather, they are due to our own bad choices that we made with the cow that we were given.

We must realise that everything comes from God, that everything is due to His will, and simultaneously we must understand that He has given us the power of discrimination and reasoning to make the right choices. It was the man's *karma* to have a flood destroy his home. It was God's kindness and compassion that sent the boat and the helicopter, but it was the man's own ignorance and obstinacy that led him to drown.

So, when a flood comes in our lives, no problem. Perhaps that was meant to happen. But, when boats and helicopters come to save us, we must recognise them for what they are — God-sent.

Accept Life for What It Is

I *have heard the story of a land called hell.* In this land, people are emaciated and famished. Yet, they are surrounded by bowls upon bowls and platters upon platters of delicious food. Why, then, are they ravished by hunger? Because, in this land called hell, their arms cannot bend and thus they cannot carry even one morsel of food from the plates to their mouths. Their hands grasp fresh bread, ripe fruits, spoonfuls of hot stew. But, in this land of hell, their bodies cannot receive nourishment for the food cannot reach their mouths. Their stick-straight arms wave wildly in the air, desperately trying to figure out a way to carry the delicious food to their mouths.

The people in hell cry out day and night. They futilely try to force their arms to bend. But the arms are stiff and straight. They try to eat directly with their mouths, but this is forbidden and they are beaten for it. So, they wither away to eternity in this land of never-ending frustration, deprivation, and starvation.

I have also heard the story of a land called heaven. In this

land as well, the people have only stick-straight arms. They, too, are surrounded by platters and bowls of sumptuous food which they cannot carry to their mouths. Yet, in heaven, everyone is plump, well-fed, satisfied and joyful. Why is this? If you look carefully you will notice that, rather than obstinately trying to bend their own unbending arms, they have simply learned to feed each other.

This is truly, the only difference between heaven and hell — do we stubbornly fight the will of God? Do we wrestle unsuccessfully each day with situations that cannot be changed? Do we flail around, wildly and desperately, trying to change the unchangeable? Do we ignore our loved ones, our friends, our colleagues who could help us immeasurably? Do we insist on suffering in silence, never asking for a helping hand from those near us? Do we watch others suffering and withhold our own help because we are so caught up in distress? If so, then we are living in hell.

Or, do we assess the situation, look around and see how the situation can be improved? Do we graciously offer our hand and our help to others? Do we accept others' help when we are in distress? Do we take joy in feeding others? Do we spend time nourishing other's bodies, minds and hearts? Do we let ourselves be fed with love? Do we allow others to nourish us, rather than thinking, 'I can do it myself?' If so, then we are living in heaven.

Too often in the world I see people who are living in the hell of their own isolation, in the hell of their own frustration, in the hell of their own determination to change the very nature of the world in which they live.

Families and friends gather frequently after many months of separation. Too frequently, though, I hear people say, "Oh, I dread this time of the year. I dread it when the whole family comes together," and then they continue a litany of complaints about this relative, that friend. I have seen innumerable situations in which family members and friends could so easily put an end to another's pain. Yet, they won't. They don't want to be the one to say, 'Here, let me feed you.'

Or, in the opposite, but similar situation, I see so many people suffering who could be helped by their families and friends. Yet, they won't ask for help. They won't let others help them. They say, 'I can do it myself.' Their pride and ego will not allow them to say, 'Will you feed me, please?' However, this is not the way it should be. When we are with our loved ones, we must realise that it is they who can feed us when we are hungry, it is they who can alleviate our suffering, it is their love which will turn our lives from hell to heaven.

But, we must be willing to see the situation as it stands. If our arms are unbending, we must accept that and then look for other ways to solve the problem. If we keep trying to change the unchangeable — in ourselves, in others or in the world — we will forever be frustrated and hungry — not only in the body, but also in the heart and the soul.

So when families and friends gather together, if you see someone suffering, be the first to offer help. Put aside any grudges or complaints or judgments; simply offer your hand in assistance. And, if you are in distress, ask for help. These are your closest family and friends. Put aside your ego and pride. See how they can help you and ask for that. Then, as you feed them and as they feed you, your lives will change from hell to heaven.

 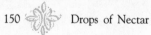

Happiness is Ephemeral

Once, Shri Guru Nanak, the founder of Sikhism and a great saint, went on a pilgrimage. This was approximately 500 years ago, and the saint travelled by foot, freely dispensing wisdom, guidance and blessings to thousands of people. Along his way, a very rich man invited Guru Nanak to his home for the night. This home could be more aptly called a palace. There was marble and gold everywhere; expensive horses and carriages; sumptuous food served out of silver dishes. Tokens of the man's success abounded.

A truly great saint is always thinking about how to help us grow spiritually, how to uplift us, how to turn our minds and hearts to God. Guru Nanak was such a saint. Additionally, a saint will never take anything without repaying the giver in some way. So, when he left the rich man's home, he handed the man a small sewing needle. "Hold on to this for me. I will take it back when I next see you," the saint said to the man.

Later, when the man told his wife what had happened, she was furious. "How could you have taken something that

belongs to a saint? What happens if he dies before he sees you again?"

It is considered a great sin to keep something that belongs to a saint or to be in a saint's debt. This is why the rich man's wife was so angry. She told her husband, "You cannot take the needle with you to heaven when you die. So, if he dies first, you will never be able to give it back to him. Go now. Return the needle immediately!" So the man set out after the saint.

When he found Guru Nanak, he handed him the needle and said, "Guruji, I cannot bear the thought that if you should die, I would have no way of returning the needle to you. It is not as though I could take it with me when I die and then give it back to you in heaven. I cannot. So, please take it now."

The saint smiled, took his needle, and looked deep into the rich man's eyes. "You are right. You cannot take this needle with you when you die. But, if you cannot even take this tiny needle, how do you think you will take all your possessions and wealth? That, too, must stay behind when you go. You cannot even leave this earth with a tiny needle, let alone a palace full of wealth."

"Oh my God, you are right." The man became white as a sheet. "All my life I have struggled for things that are as transitory as this body. I have sweated and slaved and forsaken my family in favour of acquiring more and more wealth. Yet, if God takes me tomorrow, I will lose it all in a breath. And, I have acquired nothing that will last. I have not done good deeds for others; I have not practiced *sadhana*; I have not served the world."

When he returned home, he immediately sold all his possessions — except the most basic necessities. He donated all the millions of rupees to the poor and devoted the rest of his life to God and the world. And do you know what? As he lay on his death-bed in a small, simple house with his wife and family by his side, he said, "I am far richer today than I was thirty years ago when Guru Nanak came to my house."

What can we learn from this wise saint? His message is as apt and valuable today as it was in the rural villages of India centuries ago. We come into this world with nothing but the love of our parents; we leave this world with nothing but the love we have created. All material things we acquire are left behind. I have never seen a rich man, a sportsman, a movie actress, a businessman, a doctor, a fashion model, or even the President ride to heaven in a Mercedes, carrying a basket filled with tempting snacks. No, we leave this earth alone. We cannot take our car, our favourite clothes, our finest china, not even a penny. All we can take is the *karma* of this life and the knowledge that we have spent this life in service, that the world is a better place because we lived in it.

When Alexander the Great lay dying, he begged his doctors to find some cure, to somehow salvage his failing health. The doctors sadly explained that there was nothing more they could do, that they could not give him even one extra breath. At this Alexander asked that upon his death, his arms should be kept out of his casket instead of inside. When a corpse is placed into a casket, the arms are always laid neatly at the body's side. However, Alexander wanted his

arms, palms up, out of the casket. He said that it was important for people to realise that even though he had conquered entire countries and kingdoms, even though he had obtained vast amounts of riches, even though his wealth and power were unparalleled, he still had to leave this world empty-handed. His bounty of wealth and power could neither prolong his life nor travel with him to the next world.

God is Omnipresent

A wealthy man is walking back home on a cold, windy, winter night. On his way he meets a beggar who is clad in nothing but a thin cloth. The beggar beseeches the rich man, "Please, sir, give me your shawl. Otherwise I fear I will not make it through the cold tonight."

The rich man is also a pious man, a devoted man. However, he still has a few blocks to walk. He does not want to suffer during those few blocks without a shawl. Yet, his heart is pulled by the poor man and he knows that one must always help those in need. So, he decides that the best solution is to give half of his shawl to the poor man and to keep the other half. So, he cuts the shawl in half, wraps himself in one half and gives the other to the homeless man.

That night as the wealthy man sleeps, Lord Krishna comes to him in a dream. In the dream, it is winter and Lord Krishna is shivering, wrapped only in half a shawl. "Lord, why are you wearing only half a shawl?" the man asks.

Lord Krishna replies, "Because that is all you gave me."

Our scriptures say that God comes in many forms. Frequently He comes to us in the guise of someone in need — an orphan, a homeless beggar. That is why our scriptures say to look upon everyone, whether it is a prostitute, a crippled man, a dirty child or a crook as divine. It is easy to see God in His glorious, beautiful form. It is easy to adorn the temple deity with fine clothes and sandlewood *tilak* and to cook for Him with love. It is easy to sacrifice our own needs while we do *sewa* (service) for a revered saint. It is much more difficult to extend the same love and selflessness to those in whom we don't see the direct embodiment of the Divine.

However, that is the task; that is the divine challenge. Our vision is limited. We see only the surface. We see only the outer manifestations of what we perceive to be either holiness or lowliness. And we make our judgments based on these faulty perceptions. We give to those whom we deem worthy; we give as much as we decide of the other's needs. This is our mistake, and that is why we see Lord Krishna wearing only half a shawl!

So, we must learn to cultivate divine vision. We must pray for the sight that shows us God in everyone and in everything. Who would give God only half a shawl? Who would even hesitate before offering God all we have and all we are? No one. In fact, our tradition is based on the very idea that everything we are and everything we do is for God. In *yagna* we say, *Idam namamah* (not for me, but for you). Before we eat, we offer *prasad* to God. We will not take food until He has been served first.

So, as our world is flooded with poverty, violence, hunger,

homelessness, destitution, let us open not only our two physical eyes, but let us also open our third eye, the divine eye. Let this eye show us God's existence in everyone, and let us serve others and treat others just as though they were Lord Krishna Himself who had come to us for assistance. Then, and only then, can we obliterate sorrow from the world.

Love Begets Love and Much More

A young woman heard a knock on her door one day. When she went to open it, she found an old man on her doorstep. "Come in, come in," she said.

The man asked, "Is your husband home?" The woman explained that her husband was not home, but she invited the man inside anyway.

He refused, however. "I am here with two friends," he said, pointing to two elderly men waiting in the front yard. "However, we will wait outside until your husband returns."

That evening, as soon as the husband came home, his wife told him what had happened. "Quick, quick, call them inside," the husband exclaimed. "We cannot leave old men standing in the cold outside."

So, the woman went outside and beckoned the men in. One of them rose and said, "Ma'am, actually we all cannot come in. You see, I am Love, and with me are Success and Wealth. Only one of us can enter your home. Please, go and ask your husband which of us he would like in the house."

So, the woman went and, relaying the story to her husband, said, "I think we should invite Success in. Then, you will get the promotion you've been waiting for and we will become more prosperous."

However, the husband thought and said, "But, Honey, I only want the promotion so we can be rich. If we invite Wealth into our home, then it won't matter if I get the promotion, because we will already be rich. I think Wealth is a better choice."

Their daughter then quietly spoke, "Mom, Dad, let us bring Love home. If we have Love with us, then we won't care so much about Success or Wealth. We will be rich on the inside."

Her parents thought for a moment and finally acquiesced in their daughter's wish. So, the woman went outside and, addressing the man who had introduced himself as Love, said, "Okay, we have decided. You can come inside." So, Love took a step forward and began to walk towards the house. As he passed through the doorway, the woman noticed the other two men following. "Wait," she exclaimed. "We have chosen Love. You said that only one could come inside."

Love then paused and explained gently, "If you had chosen either Success or Wealth, he would have to enter alone. However, wherever Love goes, Success and Wealth always follow."

If you ask most parents what their concerns are regarding their children, you'll hear, "I want him to get into a good university. I want her to get a good job and be successful." Time and energy are therefore expended in pushing the child

academically, encouraging the child to excel, punishing or reprimanding the child for less than a superb performance. Yet, a degree from a top university, a well-paying job, a lucrative career — these are not the true marks of 'success' in life.

True success comes when we are fulfilled, joyful, peaceful and prosperous — both internally and externally. So, fill the home with love — love for God, love for each other, love for the community, love for all of humanity. Then, through that love, through that divine connection, all else will automatically follow.

Devotion is not Blind

A long time ago, during the times when animals, men and plants still spoke the same language, there was a large fire that threatened to burn down acres of forest. Flames whipped through the ground, devouring small shrubs, bushes, flowers and grass lands. All the animals scampered for safety. Squirrels climbed high into the trees, frogs hopped quickly to lily pads in the middle of ponds, deer ran briskly to higher ground, birds flew to safety. As the fire raged, the billowing flames became more and more ominous, engulfing more and more of the forest. The waters of the pond began to boil and the frogs hopped desperately from one lily pad to another.

Soon the rising flames began to envelope even the oldest, sturdiest, densest trees. Squirrels hopped and monkeys swung from branch to branch, tree to tree, trying feverishly to escape the fury and momentum of the fire.

High on one tree sat two birds and they neither cried with fear nor attempted to fly to safety. When the forest-ranger, clothed in a fire-proof suit and attempting to ensure

the safety of as many animals as possible, saw them, he became frantic. "Fly away," he cried. "Go...shoo...fly." He yelled as loudly as he could, hoping to startle them into flight.

Yet they remained still, unwavering, complacent. The ranger picked up branches and began to throw them into the tree. "Fly away....go! Go!" He beseeched them. But the birds would not budge.

Finally, the ranger looked up and cried, "The forest is burning. This tree will be nothing but ashes in a few hours. You will die for sure. Why in the world won't you fly away?"

After many moments of silence, one of the birds spoke, "We have lived our lives on this tree. She has given us branches on which to build our nests and raise our young. She has given us fruit to eat and worms to feed to our babies. Her leaves capture the moisture each night and in the morning she has let us suck on them for water. In the summer, she has blocked the sun and provided us with shade. In the winter, she has caught the snow herself, so it would not fall on us. As the wind blows through her leaves, she sings to us. She has let us fly quickly to her highest branches to escape the tigers or other animals who would eat us. We know she will burn. If there were anything we could do to save her, we would do it. But, as much as we have tried to think of something, we realise we are helpless. There is nothing we can do. However, we will not leave her now.

"In our entire lives, and our parents' lives and our grandparents' lives, she has stood beside us, never flinching, never failing to provide us with anything we could need. How, in this most dire moment, could we abandon her? We

may not be able to save her, but we will not let her die alone. That is why we stay. She will die and we will die, but she will not leave us and we will not leave her."

We are so quick in life to switch loyalties — from one teacher to another, from one spouse to another, from one way of being to another. Our hearts are fickle. We will remain loyal as long as it serves us to do so, as long as we, too, benefit from the loyalty. But, is that really devotion? There is a reason that wedding vows include the phrase 'for richer and for poorer, in sickness and in health.'

It is very easy to be attached to someone who is healthy, happy and prosperous. It is more difficult to remain with someone who is sick, depressed and indigent. It is even more difficult to maintain devotion when it may bring what looks like harm to you. I say 'looks like harm' because the loss of faith actually is much more damaging to our soul than any of these other superficial 'catastrophes'.

Pure, single-minded devotion is one of the most beautiful things on Earth. It is, in fact, the path of *bhakti*. Yet, how many of us are really able to maintain this? Usually, we love God and have faith in Him when all is wonderful. It is more difficult to believe in the Divine when one is in agony. Know, though, that it is at times of distress that our faith is most important. For these are really the lessons of life. This is real spirituality. Spirituality is not about being where and with whom we are most comfortable. It is in keeping the fire of our loyalty burning regardless of how much water is being poured on the flames.

This is the beauty of the birds. They realised there was

nothing they could do to keep the fire away from their tree. So, they calmly and faithfully waited out God's plan. This sort of devotion may be seen as blind; it may be viewed as childish. Yet, those views from a modern, Western standpoint can only see devotion and loyalty as a means to another end. However, they are ends in and of themselves.

Their simple and pure loyalty would carry these birds' souls to heaven more than anything they would be able to accomplish with their remaining years, if they had forsaken their 'mother' tree.

Power of Love

A college professor in New York gave his business economy students the assignment of going to a slum and finding 10 children each to interview. Then, the university students had to prepare reports on each of the 10 children they had interviewed. The final item of the assignment was for the students to rate each child's chance of success in the world.

So, all the students completed their assignments. With 20 students in the class, the professor ended up with 200 papers on 200 different children living in a slum area. Every single report ended with the question: "What are this child's chances of success in the world?" Each had the same answer: "This child has no chance."

Twenty or 30 years later, another professor at the same college came upon these 200 old reports in the economy department's filing cabinets. He thought it would be interesting to see whether all the 200 children had really turned out to be victims of their impoverished, crime-ridden upbringing.

Amazingly, over 90 per cent of the children who had 'no

chance' had turned out to be successful doctors, lawyers or professionals. The professor was astonished and went to each one to ask what had helped him or her become a success. Every single respondent (now they were middle-aged) said, "Well, there was this one teacher I had who changed my life and gave me the ability to succeed."

The professor finally found this one teacher who had changed the lives of all the children. When he found her, she was past 90 and very frail. He asked her how she had possibly taken these impoverished children who had no chance of success in the world and turned more than 90 per cent of them into successful professionals. The old woman looked at the professor very simply, smiled and said, "I just loved these children."

The power of love is enough to give hope to the hopeless, enough to turn failures into successes, enough to make lives worth living.

The teacher had not taught the children any special skills. None of them recalled a particular lesson, activity or project. Rather, the simple fact that she loved them and believed in them was enough to change their lives.

We all have this power to transform not only ourselves, but others as well. Yet, do we use it? Do we take the divine gift of love in our hearts and use it as much as possible, to help as many as we can?

The message of Lord Krishna is, "Love, love and love all." From the moment He was six-days old, He had enemies. So many demons and *asuras* came to kill Him. But what did He do? Did He fight them with anger? Did He hate them?

Did He send them forever to hell? No. He granted them all liberation.

Wherever Lord Krishna went, whether it was to palaces, to the simple hut of Vidur, to the gardens of Vrindavan, He brought only His divine love. His divine love changed not only the lives of all those who met Him during His physical presence on earth, but the ever-present love He continues to shower upon us changes all who open their hearts to it.

Let us take to heart His divine message: "Love all, hate none; heal all, hurt none."

God has given us a special ability to touch others with our smiles, to change a life with a simple warm embrace, to bring meaning to the lives of others through our love. We must use this divine gift and never let it go in vain.

Flowers blossom under the warm rays of the sun and the flowers of our lives — our children, our families, and all those around us — will blossom only under the warm rays of our love.

Only God

There once lived a king, but he was not just any king. He was one of those kings who was so important, so powerful that history books would talk about him forever. This king ruled an area bigger than the land we now call America. His territory extended from sea to sea, across mountain ranges and deserts, through the jungle. No one knows how many subjects he had because there were too many to count. People used to say that if you put all his money together, in one place, it would fill the oceans.

This king was the most powerful man the world had ever seen. Anything he commanded happened instantly. They tell the story that one time in the middle of winter, the king had a craving for mangoes. But, it was winter, and we know mango trees bear fruit only in summer. However, this king was so powerful that when the mango trees heard he wanted their fruit, they began to produce huge, beautiful mangoes. The snow was washed off and the king had sweet mangoes in December.

Being such a powerful king of such a large region, he

had to travel quite a bit. And travel in those days was not as easy as it is today. There were no trains or airplanes. The king travelled by carriage, or more precisely, with an army of carriages. And, because travel was so slow and difficult, he was frequently gone for long periods of time.

One time he had been away for many months, visiting the farthest reaches of his kingdom, ensuring that everyone was happy, that everyone was taken care of. For, even though he was so rich and so powerful and had more subjects and money than one could count, he had a very pure heart and was very dedicated to all of his subjects. When he was about to return home, he sent letters to all of his queens (in those days kings had many queens). In the letters he asked if there was anything they would like, any special gift he could bring for them from far away. Of course, he always returned with carriages collapsing under the weight of gifts for his family, but he wanted to know if they had any special requests.

Each queen sent a list back to the king. "Bring me silk sarees, lined with gold...bring me diamonds, fresh out of the earth....bring me pearls from the depths of the sea...." However, while all of the other queens sent long lists, one queen sent only a piece of paper with '1' written on it. The king was baffled, for even though he was very pure and very devoted, he was not always very smart. He turned to his chief minister and said, "This queen is stupid. I knew when I married her that she was stupid. Everyone else sent a list of gifts they want. This queen writes only '1' on the paper. What is '1'?"

The chief minister was very wise; he was a true man of God, and he could see people's hearts. He laid his hand on

the king's shoulder. "No, no," he said, "the '1' means only you." She is saying that she only wants you. Everyone else wants jewels and sarees and silks. When this queen writes '1' she is saying that you are number one. That you are all she wants. If you are there with her, everything is there. In your presence, she wants nothing, needs nothing. And if you are not there, nothing can fill the hole left by your absence — not sarees, not diamonds, not jewels. If you are not there, for whom will she wear the sarees? For whom will she wear the silks, the diamonds? What is the point of all these things if you are not there? Where you are, everything is. So, she wants you to bring yourself to her and nothing else."

The king was silent. "Oh," he whispered, trembling. For now he understood. His whole life people had wanted him for what he had, for what he could do for them, what he could bring to them. He could bring wealth, he could bring possessions, he could bring health (for he had all the best doctors), he could bring grace and blessings (in those days, people believed that kings carried divine powers). But no one had ever wanted only him, just for him.

Immediately, he sent his servants to fulfil the orders on the lists sent by the other queens; he sent his messengers to deliver those orders. And he himself went to the queen. When he saw her, his eyes locked with hers. Their tears seemed to flow together. Their souls seemed to embrace, although their bodies were still many feet apart. He moved slowly, almost as though floating, towards her. And he took her in his arms and held her. "You are the only one who has ever really loved me. The others thought they loved me. But they loved me

for what I brought to them. They loved me for how they felt when they were with me. They loved me for what I symbolised. And you love me only for me."

And the king stayed there, forever, with the queen. Because of its purity, their love grew, and it showered everything near them with light and joy. Everything in their presence flourished and blossomed. Even in winter when all the other birds flew to warmer ground and the land became silent, the birds at this castle stayed and sang their blissful songs all year long. Even on cloudy days, there was always a break in the clouds big enough to ensure that the sun could shine on this castle.

And the king became even richer and even more powerful, although if you asked him, he would not have even noticed; he was too busy serving his subjects, serving God and loving his queen. And their love and light was so strong that it radiated to the farthest reaches of the kingdom, bringing joy and peace to all the creatures of the land.

So many times we become completely convinced that having this or doing that or going there will bring us happiness. 'If only I had more of this,' we say. Children are famous for this, but perhaps they are actually only more vocal. We watch TV, we see movies, we see advertisements. The message in all of these is 'Buy this, and then you will be happy.' Sure the 'happiness' takes different forms; some products bring happiness through beauty, others bring it through success, yet others bring it through the right foods. But the message is the same: Own this and you will be happy.

God is kind; God is giving. And we are His children. So, naturally, He will frequently give us what we ask for.

But when we ask for these things, aren't we saying to God, "I don't really need you, I only need this possession. Your only purpose is to bring me the possession!" If, however, we have God in our lives, we have everything.

God is the supreme king. The king of our lives. Where He is, everything is. Let us not lose sight of what it is we really need to be happy.

Service to Others is Service to Self

A princess suffered from an undiagnosable illness. She lay in bed, listless, unable to walk or to exert herself at all. She had lost all appetite and her parents feared she would soon perish. Her father, the king, called in all the top doctors and medical specialists, but none could either diagnose or cure the young princess. They gave her allopathic, homoeopathic and ayurvedic medicines. They gave her pills, compresses, powders, massages and mineral baths. Nothing made even a dent in the princess' condition. She continued to lie, limp and mute, on her bed, staring blankly at the ceiling above her.

Finally, in desperation, the king called a revered holy man, a saint who was worshipped throughout the kingdom as one with divine knowledge and powers. As soon as the sage saw the princess, he understood exactly what was wrong. "Pick her up and place her in the carriage," he ordered.

The king refused. "How can you take this weak, fragile being outside in the carriage?"

Yet, the saint insisted, "If you do not follow my orders, your daughter may not recover. Wrap her warmly if you like and place her in the carriage. We will travel alone."

The king had no choice; his options were exhausted and none had borne any fruit. He could only pray that the holy man knew what he was doing.

So the princess was wrapped in the warmest shawls and gingerly placed, supported by numerous feather pillows, in the king's carriage. The holy man got in beside her and instructed the driver where to go. He explained to the princess as they travelled, "I have a few urgent jobs to take care of on our way. You can accompany me." They soon stopped in a poor area on the outskirts of the kingdom. The sage stepped down from the carriage, carrying large sacks filled with clothing and food. He walked from house to house, delivering bags of rice, lentils, wheat to the impoverished villagers.

Soon, he returned to the carriage to find, as he had expected, the princess sitting up straight in her seat, peering eagerly over the side of the carriage. They drove a little way, and again the sage stopped the carriage in another poor, rural village outside the wealthy kingdom. "I need your help in this village. There is too much for me to carry," he told the princess. She needed the help of his hand to get down from the carriage.

The sage carried the heavy bag and gave the princess the task of handing the food items and woollen sweaters to the grateful villagers. At the first house, she walked slowly, delicately, and meekly put her hand in the large sack to take out the bags of rice and lentils.

However, by the third house she was striding confidently down the path, and by the fifth house she was picking up the young children to hold them in her arms. As they walked back to the carriage, she insisted on helping the saint carry the sacks of food and she did not need any assistance to get back into the carriage. Her cheeks were rosy; there was a beautiful, radiant smile on her face and a glow in her eyes.

Upon returning to the kingdom, three short hours after leaving, the princess nearly jumped out of the carriage and skipped up the steps to the castle! The king was amazed! How had the saint cured his daughter so completely, in such a short time?

The saint explained, "Your daughter was suffering from a lack of meaning in life. She was suffering from the disease of being spoiled and having every whim gratified. She was ill from a life being lived in vain. A journey to the poorest of the poor, a few hours of giving rather than taking, the experience of service and selflessness are the only possible cures."

Thereafter, the princess travelled twice each week with the saint, back into the poor villages, distributing food, clothing and other necessary supplies. She used her position as a princess to help improve the living conditions of all those who lived in poverty. She dedicated herself to helping all those in need.

And she never suffered from a day of listlessness again.

Every day people go to work, earn money and become more prosperous. Yet, at the end of the day, when they return home, they are not happy. What is the true secret to internal peace and everlasting joy? I always tell people, "Be God-conscious, not glamour-conscious. Have Him at the centre of

your lives and you will find peace, happiness, meaning and joy."

However, it is often difficult to know how to implement the teachings of God in daily life. Yes, we should go to the temple. Yes, we must chant His name (any name which appeals to us, whether it is Krishna, Rama, Jesus or Allah). Yes, we must read from His holy works. Yes, we must pray to Him and offer our lives to Him.

However, what else can we do, so many people ask, to really become aware of God in our daily lives? We can serve His people! Through service of the poorest of the poor, we come closest to God. It is easy to see the Divine in holy people, easy to serve those who look pious, proper and beautiful. But, the spiritual challenge is to see the Divine in all, to serve all — from the highest king to the sick leper — as though they are manifestations of God.

Through this selfless service, we not only benefit those whom we are serving, we also benefit ourselves immeasurably. Our hearts fill with joy, with peace and with love. Our lives become full of meaning.

Rise Above Adversity

A farmer had an old mule. One day the mule fell into the farmer's empty, dry well. As the mule cried for help, the farmer assessed the situation. Although the mule had served the farmer faithfully for many years, the farmer felt that neither the mule nor the well was worth the trouble. So, he decided that instead of bothering to lift the heavy mule out of the well, he would simply bury him in there. The farmer called his friend and together they began to shovel dirt into the open well.

When the first shovelful of dirt hit the mule, he panicked. 'What is this?' he thought. When the second shovelful hit him, he began to cry. 'How could the farmer do this to me?' he wondered! When the third shovelful hit him, he realised the plan. However, the mule decided that he would not allow himself to be buried alive. As each shovelful fell upon his back, he rallied himself to 'shake it off and step up'. As shovelful after shovelful of dirt hit him on his back, and as he felt dejected and pained, he continued to chant to himself, 'shake it off and step up'. This he did, shovelful after shovelful,

until, as the dirt reached the top of the well, the mule triumphantly walked out of what would have been his tomb.

If the farmer had not decided to kill the mule, the mule would never have survived. Ironically, it was the dirt which was meant to end the mule's life that actually ended up saving him, simply due to the manner in which the mule handled the situation.

In life, sometimes we feel as though the world is landing blows at us. We feel shattered and broken. We feel as though we are being 'buried alive'. Perhaps someone is actually trying to injure us; or perhaps we are simply stuck in a difficult situation. Either way, we have two choices. We can either succumb to the onslaught and allow ourselves to be buried, or we can 'shake it off and step up'. The latter is surely a more difficult path. It requires resolution, the will to survive, fortitude and faith. But, in the end, it is the path that will lead to our triumph. If we continue to 'shake off' whatever hits us in life, and we continue to 'step up' and rise above any situation, then we too can be victorious.

We are only His Tools

Several years ago, the United Nations held its 50th anniversary celebrations. World leaders — religious, political, and social — gathered to commemorate this special anniversary. Numerous renowned people gave speeches on the global significance of the UN, on the importance of fostering inter-ethnic harmony, on how to curtail the insidious trafficking of drugs, on the necessity of preserving and protecting our rapidly diminishing natural resources.

Each was allotted a short period of time in which to speak. Most were given three minutes; some were given five minutes. Time was watched carefully. Note cards were held up, alerting the speaker that he or she had three minutes left, then two minutes, then one minute.

A divine, old, revered Indian saint, clad only in scant saffron robes, walked slowly, yet purposefully and unwavering to the podium when it was time for his speech. As he spoke, silence descended upon the room. While most speeches were read from notecards, or were the product of careful and

deliberate editing, his words seemed to speak themselves. Dadaji was given five minutes to speak. However, as the organisers held up signs that read, 'Two minutes left', then 'One minute left', he showed no sign of winding up . The signs then read, '30 seconds left', then 'Finished!' However, the saint was in such ecstasy, he was so impassioned with the words that were effortlessly flowing from his mouth, that he seemed not even to notice the signs.

At first the organisers became restless and anxious. After all, there were so many other people to speak, so many other segments of this important function. How to get this saint to step down from the podium? However, as he continued, his words were like a lullaby. Even the anxious organisers became still and peaceful, mesmerised by the quality of his words and his tone. The hall, filled with an audience of thousands, was as quiet as if it were empty. Dadaji spoke for 25 minutes, an unprecedented amount of time.

When he concluded, the silence of the auditorium broke like thunder into a clamorous standing ovation. No one who was present was uncharged. The saint's words had reached not only minds, not only hearts, but also souls. He was flooded with accolades and tear-streaked faces as he descended from the stage. "Oh Dadaji, your speech was incredible. So inspiring; so uplifting. It was just wonderful." Everyone wanted to praise this elderly yet seemingly ageless Indian saint.

After one man took Dadaji's hands and gave particularly effusive praise, the saint looked sweetly into his eyes and replied, "Yes, it was wonderful. I was also listening."

'I was also listening' — this should be our *mantra*. For, it

is not we who speak. It is He who speaks, although we like to take the credit. How easy it would have been for Dadaji to have simply replied, 'Oh, yes, I know my speech was good. I spent days preparing it,' or, 'Yes. I'm a very good speaker.' However, he was a true man of God. He knew from where his words came. He knew whose words flowed through his mouth. Those who are the true inspiration, the true teachers of this world, are actually simply channels. They are not the ones who spend lifetimes refining their tenaciously-held beliefs and imposing these upon others. Rather, they simply open up the channels inside them and let God flow into their hearts and through their mouths or their pens. We are all here as tools for His work, as expressions of His love. Let us realise that; let us break the dams within us, so the river of His work and His message can flow ceaselessly through us.

A Handicapped is Less
Handicapped than Us

Across the world there is a wonderful organisation called the Special Olympics. This foundation sponsors Olympics for people who are physically and/or mentally handicapped. These are people who may be suffering from anything ranging from partial paralysis to brain damage to what is simply referred to as 'retardation'. Participating in these events not only trains the athletes to perform up to their highest potential, it also infuses them with a sense of success, of competence, of achievement.

Recently, I heard a beautiful story about a race taking place in the Special Olympics. The athletes were lined up at the mark. The official yelled, "Ready, get set, go!" and the athletes took off, all running as fast as their legs would carry them, with a look of determination, dedication and drive on their faces. All except one, that is. A young boy had tripped immediately after starting, and had fallen into the dirt. He looked forlorn as he watched his peers race off without him.

Then, suddenly, a young girl who was running, turned her head to see what had happened to the boy. As soon as she realised he had fallen, she turned around and ran back towards him. One by one, each of the athletes turned around to go back and look after the fallen boy. Soon all the runners were gathered around the young boy; they helped him to his feet as one girl brushed the dirt off his pants. Then, all the athletes held hands as they walked together, slowly, towards the finish line.

These are the people we refer to as 'handicapped' or 'retarded' or, euphemistically, as 'mentally and physically challenged'. Yet, would we, who have full use of all our limbs, whose brains function at their highest capacity, ever turn around in the middle of a race, giving up our long sought-after hope of winning and go back to look after someone who has fallen down? Would we ever sacrifice getting to the top, being the best, winning it all, just to lend encouragement to another? Rarely.

We spend our lives pushing to be higher and higher, better and better. We want to be the best, to be at the top, to be number one. But at what price? What do we give up in the process? They say, 'The mark of a true man is not how tall he stands, but how frequently he bends down to help those in need.' How frequently are we willing to bend?

The goal of life is not the accumulation of more and more possessions, or more and more degrees. The goal is to move towards God, to realise our oneness with Him. The goal is to fill every moment with compassion, with love, with prayer and with service.

Yes, of course, we must go to work and we must do our best in every possible arena. Of course, we must attempt to succeed; we must live up to our fullest potential. But, too frequently, we become narrow-minded in what we see as our 'potential'. Is our potential merely financial, or academic or professional?

Let us vow to live up to our potential — not just those that confront us obviously in our daily life, but also those which may be hidden below the surface. The athletes may have thought that their success, their achievement would be marked by how quickly they could run the 100 yards. However, the true potential of these athletes was even greater than completing a quick sprint. They chose compassion over competition; they chose unity over individual success; they chose to show us what it really means to be divine souls.

Let us take a lesson from these athletes, who are far less 'handicapped' than most people in this world. Let us learn that each race in life may have two different paths for success; let us learn that compassion, love and unity are much more everlasting achievements than a blue ribbon.

Let us vow to turn our heads around frequently and see whether, perhaps, there is someone who needs our help.

Real Education

Once there was a boat sailing in the middle of the ocean. On the boat were a philosopher, a scientist, a mathematician and the boatman. The philosopher turned to the boatman and asked, "Do you know the nuances of *Vedanta*? Do you know the theories of Plato and Aristotle?"

"No," replied the boatman. "I have never studied those things. I only know to take God's name in the morning when I wake up and at night before I sleep, and to try to keep Him with me all day long."

The philosopher looked at him with disdain. "Well, then at least 30 per cent of your life has been in vain."

Next, the scientist asked the boatman, "Do you know Einstein's Theory of Relativity? Do you know Newton's laws?"

The boatman looked out at the reflection of the moon on the water. The light seemed to dance playfully off the waves. He gently shook his head in response to the scientist's question. "No," he said. "I am not learned in that way. I have only learnt to be kind, to give more than I receive, to be humble and pious."

"Well," the scientist exclaimed. "Then at least 40 per cent of your life has been in vain."

The mathematician then turned to the boatman. "You must at least know calculus? You must know how to compute advanced equations?"

The boatman closed his eyes and entered a meditative trance. "No," he said softly, a smile creeping across his sun-weathered face. "I do not know these things."

"Then, your life has been at least 50 per cent in vain!" the mathematician retorted.

The four sat in silence for a while, when suddenly the waves began to rise up furiously; the sky turned dark, obscuring the blanket of stars. The boat, thin and wooden, began to rock back and forth, up and down, with each thrust of the waves. The boatman fought diligently, using every muscle in his body, every skill he had, to regain control over his boat. But the storm was winning the fight, and with each surge of the waves, the boatman became more and more convinced that the boat could not withstand this beating. As a wave lifted the boat high into the air, the boatman asked his passengers, "Do you know how to swim?"

"No!" they all cried at once. The wave dropped the boat, upside down, back in the raging water.

The boatman watched sadly as the scientist, the philosopher and the mathematician drowned. 'Well,' he whispered. 'I think 100 per cent of your lives have been in vain.'

In this life, there are so many things to learn, so many

things people say are important. Education is, of course, quite important. A doctor cannot operate if she doesn't know where the organs are, or how to sew a wound back up again. A scientist cannot perform experiments unless he knows which chemicals to use and how much of each. An architect cannot design buildings without knowing what foundations and supports are necessary.

However, in the big picture, these are not the lessons or the education that truly liberate us. It is not this knowledge that saves us from drowning in the ocean. Only the knowledge of God can do that. Only love for Him, devotion to Him and a life-vest inflated by Him can protect us in the raging sea of this world. For, many times in life, we feel like we are drowning. Many times we feel like we have swallowed so much water we can't breathe. It may seem as though our legs cannot possibly tread water for another minute.

At times like these we tend to turn to what we already know — our education, the acquisition of more possessions, the fulfilment of mere pleasures. However, perhaps it is these that have caused our boat to capsize in the first place. Perhaps the ominous waves of the ocean are actually made up of our insatiable desires, of our purely academic education, of our disregard for the supreme power behind and within everything.

It is the knowledge of God, of how to truly live that will save us.

Do Your Duty

There was once a horrible drought. Year after year not a drop of rain fell on to the arid ground. Crops died, and, as the land became parched, farmers gave up even sowing seed. As the time of planting and tilling the ground came for the fourth rainless year in a row, the farmers of the region, with no hope, sat listless, passing their time by playing cards and with other distractions.

However, one lone farmer continued patiently to sow seeds and till his land. The other farmers poked fun at him and derided him as he continued daily to take care of his fruitless, barren land.

When they asked him the reason behind his senseless tenacity, he said, "I am a farmer and it is my *dharma* to plant and till my land. My *dharma* does not change, whether the clouds bring rain or not. My *dharma* is my *dharma* and I must follow it, regardless of how fruitful or fruitless it appears to be."

The other farmers laughed at his wasteful effort and went back to their homes to continue bemoaning the rainless sky and their fruitless land.

However, a passing cloud happened to be overhead when the faithful farmer was giving his answer to the others. The cloud heard the farmer's beautiful words and realised, 'He's right. It is his *dharma* to sow the seeds and to till the land and it is my *dharma* to release this water which I am holding onto the ground.'

At that moment, inspired by the farmer's message, the cloud released all the water it was holding onto the farmer's land. This cloud then continued to spread the message of upholding one's *dharma* to the other clouds, and they too — upon realising it was their *dharma* to rain — began to let go of the moisture within them. Soon, rain was pouring down upon the land and the farmer's harvest was bountiful.

In life, we tend to expect results for our actions. If we do something well, we want to be rewarded. If we work, we want to be paid (whether financially or in some other way). We want to work only so long as the work reaps rewards. If the fruits cease to come, we decide the work is not 'meant to be', and we abandon it.

However, that is not the message which Lord Krishna gives to Arjuna in the *Gita*. The message is that we must do our duty regardless of the fruits. We must live according to our *dharma*, regardless of whether it appears to be successful. We must perform our duties for the simple reason that they are our duties.

Lord Krishna tells Arjuna to stand up and fight and says that, even if he dies in battle, he must still do his *dharma*. The Lord tells Arjuna that it is divine to die on the battlefield of life (meaning engaged in performing our duty). He explains

that either way, Arjuna will 'win'. If the Pandavas win the battle, then they will obliterate the evil influence of the Kauravas and inherit the kingdom. If, on the other hand, the Kauravas win the battle and the Pandavas are killed, then they will go straight to the Lord's eternal abode, for they would die in the service of *dharma*.

Usually in life, we know what our duties are. We know our responsibilities. We can see the 'right' thing to do. This is especially true if we take the time to meditate, reflect and contemplate. Yet, too frequently we walk away from doing the 'right' thing or from performing our duty due to the uncertainty of the result. We don't want to 'waste our time' or 'look like a fool'. We neglect our responsibilities by saying, 'It doesn't matter any way.' We shun our duties with words like, 'Well, no one else is doing it, so why should I?'

This is not the way to live. We must realise that there is an enormous, infinite cosmic plan at work and we must all perform our allotted tasks to the best of our ability. Whether we actually succeed or fail in the venture should not be the biggest concern. True success comes not in a financial 'win', but rather in the humble, tenacious, dedicated performance of our tasks.

Interestingly enough, when we act with righteousness and integrity, we find that others will follow. It is not that we are taken advantage of, as we frequently fear. Rather, if we set the divine example, others will follow. Just as the cloud followed the example of the tenacious farmer, so will those in our lives follow our example. If we act with honesty, we receive honesty. If we act with dedication and love, we will receive

dedication and love. If we fulfil our *dharma*, so will those around us.

Yet, even if we are the only ones acting piously, acting honestly, acting with devotion, it should not matter. Our lives, our happiness and our *karma* are individual entities. They are not dependent upon the response of others.

Therefore, we must all learn to stand up, have courage and keep performing our duties, regardless of whether it looks like success or failure. Through the fulfilment of our *dharma*, we will achieve the greatest success in life — bliss, peace and enlightenment.

Even the Most Useless is Useful

In the olden days, there was once a great king. This king had many, many servants to take care of every task. One particular servant was responsible for bringing water from the well to the king's table. However, it was a long journey from the castle to the well from which fresh, clean and pure water could be obtained. As this was the time before cars and other convenient machines were invented, the servant carried two buckets — one attached to each end of a long stick — to transport water back to the castle. One of the buckets was new — it shone in the sunlight and it was perfect in every way. The other bucket was older and it had a small hole on one side that caused water to leak from it.

Thus, whenever the servant arrived back at the castle, although he had filled two buckets of water, he had only one-and-a-half to present to the king. This caused the leaky bucket great distress. Twice a day when the servant picked up the buckets to go to the well, the older one would look longingly at the new one, 'Oh, why can't I be as shiny and flawless as the other?' the bucket would bemoan. The leaky bucket would

cast envious looks at the new bucket as not a single drop would fall from its new, glistening metal.

The leaky bucket tried every possible way of shifting its weight, of rotating its sides to minimise the leakage, but to no avail. It could retain no more than half a bucket of water through the long walk back to the castle.

One day, the leaking bucket was distraught and cried out to the servant, "Why don't you just throw me away? I'm of no use to you. I can do barely half the work of your new bucket. You have to walk such a long way, back and forth, and I leak out half the water you fill me with. The king is such a good, noble, divine king. I want to serve him as well as your new bucket. But I can't; I can't even give him a full bucket of water."

The servant was very wise (sometimes wisdom lies hidden in places where we don't expect it). He said to the bucket, "Look down. Look below you at the path to the castle, the path upon which you leak your water."

The bucket at first was too ashamed to look and see drops of precious water scattered on the ground. When it finally looked, however, it noticed a thick row of beautiful flowers — so many lush, blossoming varieties — lining the path with vibrancy and beauty.

"Every day I pick these flowers to decorate the king's table and his room," the servant said. "When I noticed that you were leaking, I planted seeds all along the path on your side of the road. Then, twice a day you water them. Now, they have grown and blossomed into the king's favourite centrepiece. He says their fragrance calms his mind and brings

Even the Most Useless is Useful

peace to his heart. So, you see, you are not useless at all. Rather, you are serving two purposes — both to bring water and also to bring beautiful flowers to the king's castle."

So many times in life we condemn ourselves for our failures, we compare ourselves unfavourably to others, we grieve over our own shortcomings, wishing that we could be different, more like someone else or some pre-conceived ideal. And as we do this, we blind ourselves to our real assets, to the flowers we are watering each day, to the real gifts we can give to the king.

God has given everyone a unique set of gifts and it is up to us to make the most of these. Some of us will be able to carry water without spilling a drop. Our gift to the world will be a full bucket of water. Others will be able to give only half a bucket of water, but we will line the world's paths with beautiful flowers and sweet fragrance. Let us never underestimate our potential or the significance of our own gifts. Let none of us ever feel like a 'leaky bucket'.

The Little Things in Life

Once there was a saint who lived in the Himalayan forests. He lived in an *ashram* deep in a beautiful jungle, where he spent his time in meditation and looking after the *ashram*.

One day, a traveller came upon the saint and the *ashram* while trekking through the Himalayas. The young man started talking to the saint about the spiritual life. The young tourist asked him, "What did you do before you became enlightened?"

The saint replied, "I used to chop wood and carry water from the well."

The man then asked, "What do you do now that you have become enlightened?" The answer was simple.

The saint replied, "I chop wood and carry water from the well."

The young man was puzzled. He said, "There seems to be no difference then. What was the point in going through all those years of *sadhana* in order to attain enlightenment if you still spend your days doing chores and menial tasks?"

The saint replied, "The difference is in me. The difference is not in my acts, it is in me: because I have changed, all my

acts have changed. Their significance has changed. Prose has become poetry, stones have become sermons and matter has completely disappeared. Now there is only God and nothing else. Life now is liberation to me; it is *nirvana*."

So many people complain, 'My job is not spiritual' or 'How can I live a spiritual life while I have to care for children and a family?' The answer lies not in *what* you're doing, but in *how* you're doing it. How attached are you to the details of what you're doing or how focused is your mind on God. A spiritual life is not about renouncing the world or renouncing tasks that we may think are beneath us. Rather, a spiritual life is about turning these tasks into *tapasya*, turning jobs into joy, turning stress into *sadhana*. This is a spiritual life.

People tend to think: first I'll complete my householder years and then I'll turn myself to God. Yes, in our culture, one dedicates one's life after retirement to God, to simplicity, to *sewa*, to spirituality. But we don't have to wait until we retire in order to attain that glorious state. We can attain it while living in the world. It's all a matter of the mind.

Attaining enlightenment does not mean being out of the world or away from tasks. It means being *in* the world, but not *of* the world. It means *doing* tasks, but not *being* the tasks.

Let us try, today, as we complete our daily routine, to ask ourselves, 'How would this routine be different if I were enlightened? How would my attitude change? How would my actions change?' Let us then pray to God for the strength to act accordingly. Then we'll know that we're really living a spiritual life and not merely relegating it to a few moments alone in the temple at the end of the day.

Connect with God

A beggar lived all his life under one tree. Each day he would go out into the villages and beg for just some dry breadcrumbs to sustain himself. Then he would come back to his tree and eat his bread or whatever scraps the villagers had given him that day. For forty years the beggar lived under the same tree, pleading with people to give him some food. He'd walk to all the nearby villages on alternate days, begging for his nourishment. Slowly, day by day, he became weaker, and finally one day his body could no longer sustain itself and he passed quietly into death.

When the villagers found him, they decided to bury his ashes under the tree where he lived out his life. As they began to dig, in order to place his ashes deep in the ground, they found a treasure-chest, full of gold, diamonds and jewels, a mere six inches below the ground.

For forty years the beggar had lived, barely scraping by on his dry breadcrumbs, sitting six inches above a treasure-chest which would have rendered him as rich as a king. If only it had ever occurred to him to explore the depths of the earth on which he sat, or to delve deep into the recesses of his home, he would have discovered this treasure-chest. But, he

did not. Rather, he sat on the surface, suffering and withering away, day by day.

Too frequently in life we are also like this beggar — running here and there, searching, begging for that which we need to fulfil our lives. Perhaps, we are not begging for food or basic necessities. More likely we are searching and yearning for peace, happiness or God. We go here, we beg there. We search this place, we search that place. But that priceless and crucial peace and happiness still elude us.

If only we would sit still for a moment and go deeper within, we would find that treasure-chest. We don't even have to dig six inches. Right within us, sitting in our heart, is God, and through our connection to Him, all the riches of the world are bestowed upon us.

However, too frequently I see people running in the opposite direction in their fruitless search. They run from this workshop to that workshop, from this new trend to that new trend, all the while being frustrated in their search. Stop for a moment and look within.

Go back to your roots, back to your heritage, back to the temple. Listen to the stories of your parents and grandparents. Perform *aarti* with deep devotion. Go to the *satsang* and take the *darshan* of visiting saints. Take a trip to India rather than to the beaches or ski slopes. Through this reconnection to your culture and your heritage you will find the key which will open the treasure-chest.

But, never forget that the treasure-chest is inside you, flowing through your veins. The divine joy is residing within us, in our heart, in our breath and in our blood.

Footprints

I heard a story once of a man who was a great devotee of God. Throughout his life, God was his companion. He loved God more than anything else in the world. When the man was very old, he lay in his bed one afternoon and had a dream. In this dream, he could see his entire life stretched out before him, as though it was the coastline along the ocean. And he could look back and see his footprints — deep impressions in the wet sand — marking the path he had walked in this life. As he looked back further and further, he could see that, in fact, there was not one, but two sets of footprints, side by side, along the edge of the ocean. He knew the other footprints were those of God, for he had felt God's presence beside him throughout his life.

But, then he saw something that woke him immediately from his dream; his heart beat fast and he could not hold back the tears. "God!" he cried out. "I just had a dream, and in this dream I could see the whole path of my life; I could see the footprints I left along the way. And besides my footprints, there were yours, for you walked with me, and..."

Now the man was full of tears and could barely speak. "But, God, sometimes there was only one set of footprints, and when I looked, I could see that those were the times I had really fallen, really broken, when I needed you most. How, God, how could you leave me when I needed you most? I thought you promised you'd be with me forever. Why did your footprints disappear at the times I really needed you?"

Softly, gently, God laid a hand on the man's head, wiped away the tears. "My child, I promised to always be with you, and I have never left you for a second, not even while you slept. Those times when you see only one set of footprints, those darkest moments of your life, it was those times that I carried you in my arms."

There are times we feel abandoned by God, times we doubt His presence in our lives. It is easy to have faith when all is going well, easy to believe in a plan when that plan brings us joy and fulfilment. It is much more difficult to believe in the inherent goodness of God when the plan causes agony. Do we all not, at some level, feel that when our lives are tough, we have been left alone by God? But, it is in those times that our faith will carry us through. It is truly those times in which we are being carried by God.

Raise Yourself; Don't Erase Others

Once, a spiritual master gave a demonstration in front of a large class. He drew a horizontal line on the board and asked the class, the following question: "Is there anyone in the room who can make this line appear shorter without erasing it?" The students thought for a while. They concluded that the only possible way to reduce the size of the line would be to erase part of it from either side.

Thus, they told Swamiji, "No, there is no way to reduce the size of the line without erasing any of it."

Swamiji then proceeded to draw another, much longer, horizontal line on the board, a few inches above the previously drawn line. "Now," he asked, "hasn't the first line become shorter in comparison to the new, longer line? Doesn't it appear quite short?" Everyone agreed that the line now appeared much shorter. "One does not have to erase a piece of the first line in order to make it appear shorter. One simply has to draw a longer line near it and it will automatically seem shorter."

In life, in the rush to get ahead, in the rush to prove ourselves and make a name for ourselves, we frequently resort

to criticising, condemning and bad-mouthing others. In order to make ourselves look better, we put other people down. So many times we talk of the shortcomings of our colleagues so that we, in comparison, will appear better, or we criticise those with whom we are in competition.

However, this is not the way to get ahead or make a name for ourselves. Let us not try to diminish others in order to look good ourselves. That is like erasing the line to make it shorter, simply so that we will look bigger in comparison. The way to get ahead in life should not be at the cost of others. Instead of putting others down, let us raise ourselves up. Instead of erasing others, let us learn how to grow.

It is very difficult in life to accept our own responsibilities, our own mistakes. It is much easier for us to condemn others, criticise others, judge others and blame others. We rarely realise how frequently our own actions contribute to a negative situation. It is so much easier to simply blame others.

A woman once went to the doctor. She told the doctor, "My husband talks all night long in his sleep. You must give me some medicine for him to make him stop talking in his sleep."

The doctor gave the woman a prescription for a medicine and told her, "If you take this medicine every day, your husband will stop talking in his sleep."

The woman was shocked, "Why must I take the medicine, doctor? It is my husband who has the problem. I am not sick. My husband is the sick one who talks in his sleep. It is for him you must prescribe the medicine."

The doctor explained to her, "Ma'am, your husband talks in his sleep because you don't let him talk during the day.

Every time he tries to say something, you correct him, belittle him or tell him to be quiet. So, he has no choice other than to talk in the night. The medicine will make you remain quiet during the day, so your husband can say what's on his mind. Then he won't have to talk in his sleep anymore!"

Whenever we are in a difficult situation, let us examine what we can do to solve the problem. Let us examine what role our own actions may have played in bringing about the current circumstances. Let us work with others to get ahead, rather than work against others. Let us cooperate instead of competing.

Indian culture teaches us *milaanaa* not *mitaanaa* and *jourma* not *tourma* [bring together, not erase; unite, not break]. But, don't break what? Don't break others' hearts and spirits with your selfishness. When we push ourselves ahead at the expense of others, we naturally hurt them in the process. We break their spirit, their enthusiasm and their self-esteem. Heights of success must not be attained by belittling others.

When Lord Rama sent Angad to Ravana in Lanka in order to bring Sita back, he told Angad, "*Kaaj hamaara taasu hita hoi.*" [Fulfil your mission in rescuing Sita, but do not hurt Ravana in the process. Just try to make him understand that he should peacefully return her]. This is the divine way: do your duty, do your best, fulfil your obligations, but don't hurt anyone in the process, either physically or emotionally.

We must dedicate our lives to growing as much as we can, to learning as much as we can, to serving as much as we can and to getting closer and closer to the ultimate goal of union with the Almighty. We must not let competition, jealousy, complexes or petty complaints stand in the way of our great mission.

Time for Spiritual Life is Now

There was once a disciple of a guru who lived a divine life of *sadhana* and *sewa* in his guru's *ashram*. One day, he went to his guru and said, "Guruji, I want to live a spiritual life. I want to live in the service of God. I want to go beyond the binding chains of this mundane, materialistic world. But, I feel that I am not quite ready. My desires for a family, for wealth and enjoyment are still too strong. Grant me some time to fulfil these wishes and then I will return to your holy feet."

So the guru said, "No problem, my child. Go. Get married, have a family and earn wealth. In 10 years I will come back for you. My blessings are with you."

With the blessings of his guru, the man went out and quickly found a beautiful girl to marry. They had three beautiful children, and the man became financially successful.

After 10 years, there was a knock on the door of their home. The man's wife opened it to see a haggard-looking beggar standing on the doorstep. The beggar asked to see her husband. At first she started scolding the beggar, thinking

that he was just there to beg for money. But the husband realised that the beggar was his guru and lovingly invited him inside.

"I have come to take you away from this world of illusions, now that you have fulfilled your desire of having a wife, family and earnings. Come with me, my son, let me show you the way to God."

But, the man looked at his guru pitifully and said, "Dear, beloved guru. Yes, you are right. You have given me my 10 years ever so generously and with your blessings I have prospered. But, my children are very young and my wife would not be able to handle the burden of all of them alone. Allow me to stay another 10 years until the children are old enough to care for themselves."

A true guru will guide you to the path, show you the light and help when help is requested, but will never force a disciple — against the disciple's will — to follow any particular path. Thus, the man's guru compassionately agreed, saying, "So be it, my son. Stay another 10 years until you feel that your mission is fulfilled."

Ten years later, the guru returned and again gave his disciple the call, "My child, I am here to take you away from this world of illusion. Your children are now grown. You have given 20 years to married life. Come now and embark on your spiritual journey."

However, the man fell at his guru's feet and cried. He said, "My divine guru, yes, it is true that 10 years have slipped by, but you see, now my children are just finishing their education and are just getting ready to marry. I cannot leave

this householder's world until I marry off my children and get them settled professionally. My youngest is 15, so if you could ever so graciously give me only 10 more years, then all of my responsibilities will be complete."

"So be it, my child," the guru said. "But remember that your true path is a spiritual path. Remember to keep your aim on God. Fulfil your duties but do not become too attached."

Ten years later, the guru returned to the house to find a large bulldog out in the front, guarding the house. He immediately recognised his disciple in the dog and saw — with his divine vision — that the man had passed away in an accident several years prior but, due to his intense protectiveness about his family and wealth, he had reincarnated as a guard-dog. The guru put his hand on the dog's head and said, "My child, now that you have regressed from a human to a dog due to your attachment to these worldly things, are you finally ready to come with me?"

The dog licked the hand of his guru lovingly and said, "My beloved Guruji. You are right that it is my own attachment which has driven me to take birth as a dog, but you see, my children have many enemies who are envious of their wealth and power. These enemies are very dangerous to my children and I must stay here to protect them. However, I am sure that within a few years, everything will sort itself out and they will be fine. Give me just seven more years to protect them; then I am yours."

The guru left and returned seven years later.

This time, there was no dog out in the front and the

home was filled with grandchildren running around. The guru closed his eyes and saw with his divine vision that his disciple had taken birth in the form of a cobra, wedged into a wall near the family safe, to guard the money. He called the grandchildren of the house. "My children," he said, "in the wall to the right of your safe, there is a cobra curled up in a small nook. Go there and bring the cobra to me. Do not kill it. It will not harm you, I promise. But, just break its back with a stick and then bring it to me."

The children were incredulous, but went to the wall where the old man had directed them. Incredibly, they saw that just as the guru had said, a cobra was curled up in the wall. Following his orders, they broke the cobra's back and carried it outside to the guru. The guru thanked the children, threw the cobra over his neck and left.

As he walked away, carrying the cobra over his neck, the guru spoke to the cobra, injured and aching, "My child, I am sorry for hurting you, but there was no other way. Thirty-seven years and three births ago, you left to taste the material world of sensory pleasures. But the ways of *maya* are so alluring and so subtle that they trap us instantly. You have wasted these lifetimes in the futile pursuit of material success and in attachment to people who also are only actors in the cosmic drama. My child, all here is *maya*, cosmic illusion. It lures us into its trap, convincing us that it is real, permanent, everlasting and significant. But, in reality, the only thing which is real is Him, and the only true purpose of life is to get close to Him. These attachments merely divert our attention and focus us away from the true purpose of life. I had no choice but to

come to your rescue as I saw you sinking deeper and deeper into the deep clutches of *maya*."

Frequently in life we think, 'just one more year' and then I will cut back on my luxuries and cut down on my time at the office. But, that 'one more year' never arrives. Our intentions are good. We want to be more spiritual. We want to devote more time to spiritual pursuits. We want to spend less, need less and serve more. We want to gain control over our lust, anger and greed. But, the power of *maya* is stronger than the power of our will. Thus, we continue to find excuses for why we must continue to work for 50 to 60 hours a week, why we still have no time for meditation, why we can't squeeze a visit to the holy places of India into our year's planning, and why we must continue to satiate our insatiable desires.

The only way to break free from the veil of illusion that *maya* wraps around our minds is to surrender to God and beg Him to show us the true light. The only way to break free is to make and stick to concrete vows of how we are going to be better people. Rather than saying, 'I will find time to meditate,' we must say, 'I will not leave for work without sitting in meditation and I will not sleep at night without doing my nightly introspection.' Rather than saying, 'I will try to come to India and visit holy places whenever I can,' we must say, 'I will take my vacation this year in India.' Rather than saying, 'I will try to cut back on my expenses so that my financial needs are less,' we must say, 'I will not buy another jacket or pair of shoes [or anything] until the ones that I have are broken, torn or no longer fit me.' Rather than saying, 'I will try to overcome my anger, lust and greed,' we must commit

to having daily appointments with God in which we introspect on all the times we allowed ourselves to be overpowered by these emotions, and we must pray for strength daily, to remain calm, peaceful and *sattvic* in our lives.

If we wait for the right time, that time will never come. The only time is now.

Personal Perception Causes Pain

A man once went to see a doctor, complaining of aches and pains all over his body. "Doctor, my whole body hurts," he moaned. The doctor asked him to show exactly where the pain was.

The man explained, "When I touch my shoulder, it hurts. When I touch my back it hurts. When I touch my legs, they hurt."

The doctor did a thorough examination and told the man, "Sir, there is nothing wrong with your body. Your finger is broken, that is why it hurts wherever you touch. Get your finger plastered; rest it for a couple of weeks and your pain will disappear."

In life, frequently it is our perspective that causes us pain. As we go through life 'feeling' the world with our fingers, if our finger is broken, we will obviously experience pain everywhere. But, we make the mistake of blaming the external world for our ailments: 'My job is over-taxing, my husband is too demanding, my wife nags, my children are disobedient, my in-laws don't understand me, etc. etc.' But somewhere in

the world, we will find someone who has the same type of job but is calm, or someone who has the same type of spouse but is happy, or someone who has the same type of children but is patient, or someone who has the same type of in-laws but is grateful.

What is it that allows two people to experience the same external situation but respond in two different ways? Our own perspective; our own perception. The key, then, is not to try to change every situation in our life, but rather to change the glasses through which we see the world. Sure, if we have a fixed situation at the office or at home, we will definitely do our best to improve it. But, what I have seen is that if someone has the nature to be dissatisfied or pained, that person's nature is not going to change simply by changing the external situation.

A massage for the back, shoulder or legs or a chiropractic or acupuncture treatment would not help the man in our earlier example because it is his finger which is broken. He could spend hundreds of dollars to ease the pain in his body, but unless he puts his broken finger in a splint, he will continue to experience pain every time that finger touches other parts of his body. Similarly, we go through life trying to 'fix' our jobs or marriages or family life, but frequently the problem lies in our own perspective. If we spend the same amount of energy 'fixing' our perspective as we spend trying to 'fix' our spouse or children, everything would be fine.

This is not to say that pains and troubles don't really exist in our day-to-day life. Of course, they do. The man in our example may also have a stiff back or sore shoulders, but the

excruciating pain he experienced was due not to the minor aches and pains in his body, but due to the severely broken finger with which he was touching them. Similarly, our jobs and our families are taxing. They demand a lot out of us. However, the unbearable pain is due not to the demands from without, but due to the demands from within ourselves.

In the *Gita* it is said that we are our best friend and also our own worst enemy, depending upon how we live our lives.

What is it within ourselves that causes us to experience pain in the world? What irrational fear, what desire, what motive, what ego-driven need has broken the finger with which we feel the world or what has coloured the glasses with which we see? We spend so much time examining others, but very little time examining our own selves.

The source of all joy and peace lies within us. We are distanced from that source by a host of desires, fears and ignorance. The key to finding and tapping into that source must come from within. Let us find the key within ourselves and unleash the source of divine bliss in our lives.

Happiness Lies Within

Once, a woman was standing in the street, searching for something under a bright street lamp. A wise man walked by and asked her, "Mother, what are you searching for?"

She replied, "I have lost my needle and I am looking for it."

The man helped her search it for quite some time, all to no avail. Finally, he asked, "Mother, where exactly did you lose your needle?"

She replied, "I was sewing inside on the chair and the needle was lost there."

The wise man queried, "But Mother, if you lost your needle inside, then why are you searching outside for it?"

The woman answered, "Because inside it is dark and I cannot see. Here, with the light of this lamp, I can see easily and search for my needle."

The wise man counselled her, "Mother, go back inside. It may be dark and difficult to see, but your needle is inside.

Light a candle and search inside. You will never find your needle out here."

This old woman might seem strange to us. Yet, don't we do the same thing in our lives? We look outside for our happiness, for our fulfilment and for our joy. We look to possessions to fulfil us. We think that if we have the latest car, a new CD or a new pair of shoes, then we will be happy. When we feel depressed or stressed, what do we do? We go shopping or we go on a holiday to the beach.

Yet, we all know that happiness and peace are not there. We are never truly happier or more peaceful the day after buying something new than we were before. In fact, we frequently forget that we even bought it! The new coat, pair of shoes or CD gets locked away in a closet or store-room and we forget about it.

The reason that these things don't bring happiness is that we may have a new coat, but it is still being worn by the same person. We may have new shoes, but they are covering the same feet. We may be driving a new car, but the driver is the same. We may be in Hawaii or Tahiti or on a cruise ship, but we are still the same person, and the pain comes from within, not from without. If dissatisfaction and pain come from within, then how can satisfaction and joy come from without?

They cannot. The sooner we realise that the true answer lies within — in our hearts, in our relationship to God, in our inner selves — the quicker we will find that answer. It is a rare person, though, who pauses to look inward for answers. Most of us are so busy searching shopping malls, vacation catalogues and our relationships with other people for the answers.

Why do we look outside? Because it is easier. It is easier to examine other people than our own selves. So we search for these things and these other people for the key to our happiness. But, although the light is there, the needle is not.

We must go inward, even though it seems dark and even though it seems that we may never find anything. We must have faith and start searching. Meditation, prayer, faith in God, spiritual practice, a *guru*, introspection, silence — these are all things that light the way for us to look inward, to find that needle.

Our candle may be dim at first; it might be hard to see. But slowly that candle will get brighter, and we will eventually find the needle which we lost. However, the longer we search outside, the longer our needle will remain lost.

I pray that you all may turn inward. I don't mean that you should ignore your family and friends or not buy gifts for your children. Rather, as you enjoy the time with your family and as you enjoy the gifts you receive, please remember that nowhere, other than within your own heart, lies the true answer to your happiness. Love your family without expectation. Enjoy the material gifts without expectation. Enjoy the vacation without expectation. When we expect these external things, people and places to bring us the ultimate bliss in life, that is when we will be disappointed. When we love and appreciate them as they are, but turn inward and to God for true bliss, that is when we will be satisfied, both externally and internally.

Do not Shirk Your Duty

Once there was a *sadhu*, a renunciant, living on the banks of a river, performing his *sadhana* with great piety and determination.

One day, as the holy man went for his bath in the river, he noticed a scorpion struggling in the water. Scorpions cannot swim, and the *sadhu* knew that if he did not save the scorpion, it would drown. Therefore, carefully picking up the scorpion, the saint lifted it out of the waters and was just about to set it down gently on the land when the scorpion stung his finger. In pain, the *sadhu* instinctively shook his hand and the scorpion went flying, back into the river.

As soon as the *sadhu* regained his composure from the sting, he again lifted the drowning scorpion out of the water. Again, before he could set the scorpion safely on land, the creature stung him. Again, as the *sadhu* shook his hand in response to the pain, the scorpion fell back into the water. This exchange went on for several minutes as the holy man continued to try to save the life of the drowning scorpion and the scorpion continued to sting his saviour's hand before reaching the safety of the river bank.

A man, who had been out hunting in the forest, noticed this interaction between the holy man and the scorpion. He watched as the saint carefully and gingerly lifted the creature out of the water, only to fling it back in, as his hand convulsed in pain from each fresh sting. Finally, the hunter said to the *sadhu*, "Revered Swamiji, forgive me for my frankness, but it is clear that the scorpion is simply going to continue to sting you each and every time you try to carry it to safety. Why don't you give up and just let the evil creature drown?"

The holy man replied, "My dear child, the scorpion is not stinging me out of malice or evil intent. It is simply his nature to sting. Just as it is the water's nature to make me wet, so it is the scorpion's nature to sting in order to protect himself. He doesn't realise that I am carrying him to safety. That is a level of conscious comprehension greater than what his brain can achieve. But, just as it is the scorpion's nature to sting, so it is my nature to save. Just as he deos not betray his nature, why should I betray mine? My *dharma* is to help any creature of any kind, human or animal. Why should I let a small scorpion rob me of the divine nature which I have cultivated through years of *sadhana*?"

In our lives we encounter people who harm us, who insult us, who plot against us and whose actions seem calculated simply to thwart the success achieved by us. Sometimes these are obvious acts, such as a co-worker who continually steals our ideas or speaks badly of us to our boss. Sometimes these acts are more subtle — a friend, relative or colleague who unexpectedly betrays us or who surreptitiously speaks negatively about us behind our back. We often wonder,

'How could he/she hurt me like that? How could they do this to me?' Then, our hearts become filled with anger and pain, and our minds start plotting vengeance.

Slowly, we find that our own actions, words and thoughts are prone to anger and pain. We find ourselves engaged in thoughts of revenge. The other person insulted us, plotted against us or interfered with a well-deserved achievement at work. But we injure ourselves more deeply and more gravely by allowing our hearts and minds to turn dark.

Our *dharma* is to be kind, pure, honest, giving, sharing, and caring. Others, due to ignorance, due to lack of understanding (much like the scorpion who could not fathom the *sadhu's* sincere intention) or due to the way in which their own *arm* drama must unfold, may act with malice, deceit, selfishness and indifference. But we must not let their actions or their ignorance deprive us of fulfilling our *dharma*.

Sometimes people ask, "But Swamiji, how long should we continue to tolerate, to forgive, to love in the face of other people's aggression, jealousy, hatred and malice?" The answer is, "Forever." It is not our job to hand out punishment to others based on their negative actions. That is God's job and the job of the law of *karma*. They will get their punishment. Do not worry. They will face the same misery they are bringing to us. It is God's job and, with the precise law and science of *karma,* evil-doers will receive punishment. But not at our hands. If we allow ourselves to injure them, insult them, plot against them and hurt them, then we are simply accruing more and more negative *karma* for ourselves.

If the *sadhu* had allowed the scorpion to suffer and drown in the river, he would have forsaken his own divine path in life. Sure, we can say that the scorpion deserved to die for what he did to the *sadhu*. We can say that the *sadhu* tried to save the scorpion but the scorpion would not let him. We can give a list of explanations to excuse the *sadhu* for not rescuing the scorpion. But, to pardon bad behavior is not our goal. To excuse ourselves for failing to fulfil our duties is not the goal. The goal is to live up to our full, divine potential as conscious, holy beings.

So, let us pledge to always remember what our *dharma* is — to live a life of purity, piety, peace, selflessness, integrity and love — and let us never allow anyone to divert us from that goal.

How to Walk on the Path of Life

When I was very young, not long after I came to Parmarth Niketan, a very old, revered saint came to Rishikesh to give his divine *satsang* at Parmarth Niketan.

However, rather than staying in the comforts of the *ashram*, he used to stay in a small hut on the banks of River Ganga, a little distance away from the *ashram*.

I was given the special *sewa* (service) of going to pick him up each morning to bring him to the *ashram*. As we would walk through the busy market-place, I would try to push everyone and everything out of his way so that the revered saint could walk comfortably and unimpeded to the *ashram*. I would tell everyone along the way, "Move aside please. Please give us way." I would gently push all the wandering cows out of his path. I would move stationary bicycles and fruit carts out of the way so that he could pass.

Finally, as we would reach the gate of the *ashram*, I would feel very glad that I had been able to bring him safely to the *ashram*.

This saint, however, looked at me lovingly one day and said, "*Beta, kis kis ko hatate rahoge? Aur kab tak hatate rahoge?* (My child, how many people and cows can you push out of the way? For how long can you move other people and things out of your path?) "*Apna rasta banate jao. Apna rasta banake nikalte jao.* (Make your own path, but do not worry about moving others. Find your own way in the midst of the chaos)."

In our lives we frequently get frustrated when we find others blocking our way and thwarting our progress. We blame their presence and their actions for our own failure. We explain to ourselves that we would have been able to succeed if only they had let us, if only they had moved out of the way for us. We try to push people and obstacles aside to clear a way for ourselves in life.

However, obstacles never cease. People who are jealous, never stop trying to block our path. For how long can we try to move them aside? How many obstacles, how many enemies can we try to push away? The answer is to simply find our own way, around them, between them. If they block the path to the right, we walk to the left. If they block the path to the left, we walk to the right.

We must be more concerned about finding our own way rather than focussing on moving aside all of those whom we think are blocking our path. For those who are pure in mind, thought and deed, there will always be a path to walk. The path may be narrow at times and it may seem that obstacles and enemies line both the sides. But we must humbly and sincerely make our own way on the path of life. We must keep walking the path of our *dharma*, the path of righteousness,

the path of honesty, purity and piety without worrying about those who try to block our way.

The more attention we give to those who try to sabotage us and thwart our progress, the less time and energy we have to walk the right path. That way, then, the enemies win, for they have stolen our peace of mind, our tranquillity, our joy and also our time. Instead of trying to fight them, we must remain humble, pure and single-mindedly concentrate on the goal. If we can see our destination clearly, then we will always be able to find a path on which to walk.

So, keep the destination fixed in your mind. Stay focused on the goal and *nikalte chale, nikalte chale jao* (move around the obstacles and continue on the path).

Give
Kahlil Gibran

You give but little when you give
of your possessions.

It is when you give of yourself that you truly give.

For what are your possessions but things you keep and
guard

for fear you may need them tomorrow?

And tomorrow? What shall tomorrow bring to the over-
prudent dog burying bones in the trackless sand as he follows
the pilgrims to the holy city?

And what is the fear of need but need itself?

Is not dread of thirst when your well is full,

the thirst that is unquenchable?

There are those who give little of the much they have—
and they give it for recognition, and their hidden desire makes
their gifts unwholesome.

And there are those who have little and give it all.

These are the believers in life and in the bounty of life, and their coffer is never empty.

There are those who give with joy,

and that joy is their reward.

And there are those who give with pain,

and that pain is their baptism.

And there are those who give and have not pain in giving, nor do they seek joy, nor give with mindfulness of virtue; they give as in yonder valley the myrtle breathes its fragrance into space.

Through the hand of such as these,

God speaks, and from behind their eyes,

He smiles upon the earth.

It is well to give when asked, but it is better to give unasked through understanding.

And to the open-handed the search for one who shall receive is a joy greater than giving.

And is there aught you would withhold?

All you have shall some day be given;

therefore give now, that the season of giving may be yours and not your inheritors.

You often say,

"I would give, but only to the deserving."

The trees in your orchard say not so,

nor the flocks in your pasture.

They give that they may live,

for to withhold is to perish.

Surely he who is worthy to receive his days and his nights is worthy of all else from you.

And he who has deserved to drink from the ocean of life deserves to fill his cup from your little stream.

And what desert greater shall there be,

than that which lies in the courage and the confidence, nay the charity of receiving?

And who are you that men should rend their bosom and unveil their pride, that you may see their worth naked and their pride unabashed?

See first that you yourself deserve to be a giver, and an instrument of giving.

For, in truth it is life that gives unto life, while you, who deem yourself a giver, are but a witness.

And you receivers — and you are all receivers — assume no weight of gratitude, lest you lay a yoke upon yourself and upon he who gives;

rather, rise together with the giver on his gifts, as on wings.

Reasons to Give Thanks

If we wake up this morning with more health than illness, we are more blessed than the million who will not survive the week.

If we have never experienced the danger of battle, the loneliness of imprisonment, the agony of torture or the pangs of starvation, we are ahead of 500 million people around the world.

If we attend a temple or church meeting without fear of harassment, arrest or torture of death, we are more blessed that almost three billion people in the world.

If we have food in our refrigerator, clothes on our back, a roof over our head and a place to sleep, we are richer than 75 per cent of this world.

If we have money in the bank, in our wallet, and spare change in a dish someplace, we are among the top 8 per cent of the world's wealthy.

If we hold up our head with a smile on our face and are

truly thankful, we are blessed because the majority can, but most do not.

If we can hold someone's hand, hug them or even touch them on the shoulder, we are blessed because we can offer God's healing touch.

If we prayed yesterday and today, we are in the minority because we believe in God's willingness to hear and answer prayers.

If we can read this message, we are more blessed than over two billion people in the world who cannot read anything at all.

Ways to Overcome Stress
J.P. Vaswani

- Fill your mind with thoughts of God; wake up in the morning with a great thought of the Great One or a text from a scripture dear to you.

- Close the day by reading some positive literature.

- Practice the presence of God.

- Never neglect your daily appointment with God.

- Breathe out peace, love and blessings to all.

- Forgive before forgiveness is asked.

- Help others.

- Be relaxed at all times.

- Develop a healthy sense of humour.

- Always see the bright side of things.

- Develop faith in the goodness and caring power of God.

- In all conditions of life, let the words 'Thank you, God' be on your lips all the time.

Beauty Secrets
Audrey Hepburn

- For attractive lips, speak words of kindness.

- For lovely eyes, seek out the good in people.

- For a lovely figure, share your food with the hungry.

- For beautiful hair, let a child run his or her fingers through it once a day.

- For poise, walk with the knowledge that you'll never walk alone.

- People, even more than things, have to be restored, renewed, revived, reclaimed and redeemed.

- Never throw out anybody.

- Remember, if you ever need a helping hand, you'll find one at the end of your arm.

- As you grow older, you will discover that you have two hands: one for helping yourself and one for helping others.

- The beauty of a woman is not in the clothes she wears, the figure that she carries, or the way she combs her hair.

- The beauty of a woman must be seen in her eyes, because that is the doorway to her heart.

- The beauty of a woman is not in a facial mole, but true beauty in a woman is reflected in her soul.

- It is the caring that she lovingly gives, the passion that she shows, and the beauty of a woman with passing years only grows!

Reflections on Life
Gabriel Garcia Marquez

If for an instant God were to forget that I am a rag doll and gift me with a piece of life, possibly I wouldn't say all that I think, but rather I would think of all that I say. I would value things not for their worth but for what they mean. I would sleep little, dream more, understanding that for each minute we close our eyes, we lose 60 seconds of light.

I would walk when others hold back, I would wake when others sleep. I would listen when others talk, and how I would enjoy a good chocolate ice-cream! If God were to give me a piece of life, I would dress simply, throw myself face first into the sun, baring not only my body but also my soul.

My God, if I had a heart, I would write my hate on ice, and wait for the sun to show. Over the stars I would paint with a Van Gogh dream, a Benedetti poem, and a Serrat song would be the serenade I'd offer to the moon. With my tears I would water roses, to feel the pain of their thorns, and the red kiss of their petals...

My God, if I had a piece of life, I wouldn't let a single day pass without telling the people I love that I love them. I would convince each woman and each man that they are my favourites, and I would live in love with love. I would show men how very wrong they are to think that they cease to be in love when they grow old, not knowing that they grow old when they cease to be in love! To a child I shall give wings, but I shall let him learn to fly on his own. I would teach the old that death does not come with old age, but with forgetting.

I have learned that everyone wants to live on the peak of the mountain, without knowing that real happiness is in how it is scaled. I have learned that when a newborn child squeezes for the first time with his tiny fist his father's finger, he has him trapped forever. I have learned that a man has the right to look down on another only when he has to help the other to get to his feet.

I have learned so many things, but in truth they won't be of much use, for when I keep them within this suitcase, unhappily shall I be dying.

(*From GABRIEL GARCIA MARQUEZ when facing death due to cancer.*)

The Paradox of Our Times

The paradox of our time in history is that
we have taller buildings but shorter tempers;
wider freeways, but narrower viewpoints.
We spend more, but have less;
we buy more but enjoy less.

We have bigger houses and smaller families,
more conveniences, but less time;
we have more degrees, but less sense;
more knowledge, but less judgment;
more experts, yet more problems;
more medicine, but less wellness.

We drink too much, smoke too much,
spend too recklessly,
laugh too little,

drive too fast,

get too angry,

stay up too late, get up too tired,

read too little, watch TV too much, and pray too seldom.

We have multiplied our possessions, but reduced our values.

We talk too much, love too seldom, and hate too often.

We've learned how to make a living, but not a life;

we've added years to life, not life to years.

We've been all the way to the moon and back, but have trouble crossing the street to meet a new neighbour.

We conquered outer space, but not inner space.

We've done larger things, but not better things.

We've cleaned up the air, but polluted the soul.

We've conquered the atom, but not our prejudice.

We write more, but learn less.

We plan more, but accomplish less.

We've learned to rush, but not to wait.

We build more computers to hold more information to produce more copies than ever,

but we communicate less and less.

These are the times of fast foods and slow digestion;

big men and small character;

steep profits and shallow relationships.

These are the days of two incomes but more divorce,
fancier houses but broken homes.

These are days of quick trips, disposable diapers,

throwaway morality, one-night stands, overweight bodies,
and pills that do everything from cheer to quiet to kill.

It is a time when there is much in the show-window and
nothing in the stockroom.

I've Learned

I've learned that no matter what happens, or how bad it seems today,

life does go on, and it will be better tomorrow.

I've learned that we can tell a lot about a person by the way he/she handles these three things:

a rainy day, lost luggage, and tangled Christmas tree lights.

I've learned that regardless of our relationship with our parents, we'll miss them when they're gone from our life.

I've learned that making a 'living' is not the same as making a 'life'.

I've learned that life sometimes gives us a second chance.

I've learned that we shouldn't go through life with a catcher's mit in both hands.

We need to be able to throw something back.

I've learned that if we pursue happiness, it will elude us. But if we focus on our family, our friends, the needs of others,

our work and doing the best we can,

happiness will find us.

I've learned that whenever I decide something with an open heart, I usually make the right decision.

I've learned that even when I have pain, I don't have to be one.

I've learned that every day we should reach out and touch someone. People love that human touch — holding hands, a warm hug, or just a friendly pat on the back.

People will forget what we said, people will forget what we did,

but people will never forget how we made them feel.

Without the Master
Kabir

A temple roof
cannot stay up without rafters;
so without a name
how can one cross the ocean?

Without a vessel
water cannot be kept;
so without a saint
man cannot be saved from doom.

Woe to him
who thinks not of God,
whose mind and heart
remain absorbed in ploughing
the field of the senses.

Without a ploughman,
land cannot be tilled.
Without a thread
jewels cannot be strung.
Without a knot
the sacred tie cannot be made;
so without a saint
man cannot be saved from doom.

A child cannot be born
without father and mother.
Clothes cannot be washed
without water.
There can be no horseman
without a horse;
so without a master,
none can reach the court of the Lord.

Without music
there can be no wedding.
Rejected by her husband,
a bad woman suffers misery;
so man suffers
without a saint.

Says Kabir, "My friend,
only one thing attain:
become a *gurumukh*
that you do not die again."

Watch and Listen Carefully

The man whispered, "God, speak to me,"
and a meadow lark sang.
But the man did not hear.

So the man yelled, "God, speak to me!"
And the thunder rolled across the sky.
But the man did not listen.

The man looked around and said, "God, let me see you."
And a star shined brightly
but the man did not notice.

Then the man shouted, "God, show me a miracle!"
And a life was born.
But the man did not know.

So the man cried out in despair, "Touch me God, and let me know you are here!"

Whereupon, God reached down and touched the man.

But the man brushed the butterfly away and walked on.

I Am Thankful

For the teenager who is not doing dishes, but is watching TV, because it means he is at home and not on the streets.

For the taxes that I pay,
because it means that I am employed.

For the mess to clean up after a party,
because it means I have been surrounded by friends.

For the clothes that fit a little too snugly,
because it means I have enough to eat.

For my shadow that watches me work,
because it means that I am out in the sunshine.

For a lawn that needs mowing, windows that need cleaning, and gutters that need fixing,

because it means that I have a home.
For all the complaints I hear about the government,
because it means that we have freedom of speech.

For the parking spot I find at the far end of the parking
lot, because it means I am capable of walking and that
I have been blessed with transportation.

For my huge heating bill,
because it means that I am warm.

For the lady behind me in church who sings off key,
because it means that I can hear.

For the pile of laundry and ironing I have to do,
because it means I have clothes to wear.

For the weariness and aching muscles at the end of the
day,
because it means that I am capable of working hard and
that I have employment.

For the alarm that goes off early in the morning,
because it means that I am alive.

Rules for Students
Bill Gates

Rule 1 - Life is not fair; get used to it!

Rule 2 - The world won't care about your self-esteem. The world will expect you to accomplish something before you feel good about yourself.

Rule 3 - You will *not* make $40,000 a year right out of high school. You won't be a vice-president with a car phone, until you earn both.

Rule 4 - If you think your teacher is tough, wait till you get a boss. He doesn't have a tenure.

Rule 5 - Flipping burgers is not beneath your dignity. Your grandparents had a different word for burger-flipping; they called it opportunity.

Rule 6 - Your school may have done away with winners and losers, but life has not. In some schools, they have abolished failing grades; they'll give you as many times as you want to get the right answer. This doesn't bear the slightest resemblance to *anything* in real life.

Rule 7 - Before you were born, your parents weren't as boring as they are now. They got that way from paying your bills, cleaning your clothes and listening to you talk about how cool you are. So, before you save the rain-forest from the parasites of your parents' generation, try 'delousing' the closet in your own room.

Rule 8 - If you mess up, it's not your parents' fault, so don't whine about your mistakes; learn from them.

Rule 9 - Life is not divided into semesters. You don't get summers off and very few employers are interested in helping you find yourself. Do that in your own time.

Rule 10 - Television is *not* real life. In real life, people actually have to leave the coffee shop and go to jobs.

Rule 11 - Be nice to nerds. Chances are you'll end up working for one.

God's Perfection

In Brooklyn, New York, Chush is a school that caters to teaching disabled children. Some children remain in Chush for their entire school career, while others can be mainstreamed into conventional schools.

At a Chush fund-raising dinner, the father of a Chush child delivered a speech that would never be forgotten by all who attended. After extolling the school and its dedicated staff, he cried out, "Where is the perfection in my son, Shaya? Everything God does is done with perfection. But my child cannot understand things as other children do. My child cannot remember facts and figures as other children do. Where is God's perfection?" The audience was shocked by the question, pained by the father's anguish and stilled by the piercing query.

"I believe," the father answered, "that when God brings a child like this into the world, the perfection that he seeks is in the way people react to this child." He then told the following story about his son, Shaya.

One afternoon, Shaya and I walked past a park where some boys whom Shaya knew were playing baseball.

Shaya asked, "Do you think they will let me play?"

I knew that my son was not at all athletic, and that most boys would not want him on their team. But I understood that if my son was chosen to play, it would give him a comfortable sense of belonging. I approached one of the boys in the field and asked if Shaya could play. The boy looked around for guidance from his team-mates. Getting none, he took matters into his own hands, and said, "We are losing by six runs and the game is in the eighth inning. I guess he can be on our team, and we'll try to put him up to bat in the ninth inning." I was ecstatic as Shaya smiled broadly.

Shaya was to put on a glove and go out to play short centre-field. At the end of the eighth inning, Shaya's team scored a few runs, but was still behind by three. At the end of the ninth inning, Shaya's team scored again, and, now with two outs and the bases loaded with the potential winning run on base, Shaya was scheduled to be up. Would the team actually let Shaya bat at this juncture and give away its chance to win the game? Surprisingly, Shaya was given the bat. Everyone knew that it was all but impossible because Shaya didn't even know how to hold the bat properly, let alone hit with it.

However, as Shaya stepped up to the plate, the pitcher moved a few steps to lob the ball in softly so Shaya should at least be able to make contact. The first pitch came, and Shaya swung, clumsily and missed. One of Shaya's team-mates came up to Shaya and together they held the bat and

faced the pitcher, waiting for the next pitch. The pitcher again took a few steps forward to toss the ball softly toward Shaya.

As the pitch came in, Shaya and his team-mate swung at the ball and together they hit a slow ground ball to the pitcher. The pitcher picked up the soft grounder and could easily have thrown the ball to the first baseman. Shaya would have been out and that would have ended the game.

Instead, the pitcher took the ball and threw it in a high arc to right field, far beyond the reach of the first baseman. Everyone started yelling, "Shaya, run to first. Run to first." Never in his life had Shaya run to first. He scampered down the baseline, wide-eyed and startled. By the time he reached the first base, the right fielder had the ball. He could have thrown the ball to the second baseman who would tag out Shaya, who was still running. But the right fielder understood what the pitcher's intentions were, so he threw the ball high and far over the third baseman's head.

Everyone yelled, "Run to second, run to second." Shaya ran towards second base as the runners ahead of him deliriously circled the bases towards home. As Shaya reached the second base, the opposing short-stop ran to him, turned him in the direction of third base and shouted, "Run to the third."

As Shaya rounded the third, the boys from both teams ran behind him, screaming, "Shaya run home."

Shaya ran home, stepped on home plate and all the 18 boys lifted him on their shoulders and made him the hero, as he had just hit a 'grand slam' and won the game for his team.

"That day," said the father, softly, "those 18 boys reached their level of God's perfection."

249 God's Perfection

Glossary

A*arti* is a Hindu ritual in which light from wicks soaked in *ghee* (clarified butter) or camphor is offered to one or more deities. It may also refer to the traditional song that is sung in the ritual with the same name.

Adharma is irreligiosity. Blind faith, that which disregards the cosmic principles leads to *adharma*.

Agamic is occurring or reproducing without the union of male and female cells; asexual.

Agni is fire.

Ahimsa is a Hindu doctrine expressing belief in the sacredness of all living creatures and urging the avoidance of harm and violence.

Akash is the sky.

Archana is a *puja* performed to seek the blessings of the Lord. It can be performed at any time.

Asana is a Sanskrit word that literally means a seat but in the practice of yoga refers to a pose or posture. In Patanjali's *Yoga Sutra*, *asana* means, mainly, sitting for meditation.

Ashrams in ancient India were Hindu hermitages where sages used to live in peace and tranquillity amidst Nature. Their purpose apart from performing sacrifices and penances was also to use them for education.

Asuras, in Hindu mythology, are a group of power-seeking deities, sometimes misleadingly referred to as demons. They were opposed to the *devas*.

Atharva Veda is a sacred text of Hinduism and part of the four books of the *Vedas*. It derives from the Indo-Aryan name *Atharavan*, a term which is usually taken to mean a fire priest in Sanskrit.

Bhakta is a term for a person who practices *bhakti*, that is, loving devotion for God. It can also mean a follower.

Bhakti is the devotional way of achieving salvation, emphasising the loving faith of a devotee for a deity and open to all persons.

Darshan means sight. It is most commonly used for visions of the Divine, that is, of a God or a very holy person or deity in a temple.

Deva is the Sanskrit word for God or deity. In Hindu mythology, the *devas* are opposed to the demonic *asuras* (demons).

Dharma is the doctrine the religious and moral rights and duties of each individual; it generally refers to religious duty, but may also mean social order, right conduct, or simply virtue.

Dhoti is a style of Indian men's wear. A rectangular piece of cloth, it is wrapped in a complex manner about the waist

and the legs.

Ekadashi is the eleventh lunar day of the *shukla* (bright) or *krishna* (dark) *paksha* (fortnight) respectively, of every lunar month in the Hindu calendar.

Ganga is a river of northern India rising in the Himalayan mountains and flowing for about 2,510 km, generally eastward through a vast plain to the Bay of Bengal. The river is sacred to the Hindus.

Garbha-griha is the inner sanctum or womb-chamber in the temple that houses the idols or images of God.

Gita is a sacred Hindu text that is incorporated into the *Mahabharata* and takes the form of a philosophical dialogue in which Krishna instructs Arjuna in ethical matters and the nature of God.

Guna in an abstract use may mean 'a subdivision, species, kind', and generally refers to 'quality'.

Guru is an advisor or teacher. The term, which comes from Hinduism, refers to a spiritual teacher. *Gu* means darkness, and *ru* means light; thus a guru turns ignorance into enlightenment.

Gyan is knowledge.

Hanuman Chalisa (40 verses about Shri Hanuman) teaches us how we can purify our lives and be successful in all our efforts just as Hanuman was successful.

Ishta-deva or *ishta devata* is a revered aspect of God chosen by a devotee.

Janmashtami is observed on the eighth day of the *Bhadrapadha* month according to the Hindu calendar.

Japa is the process in which a devotee repeats the name of God. This is considered as one of the most effective spiritual practices.

Jal is water.

Jatis comprise the sub-castes found within the four major castes in the Hindu system.

Jyotishis are fortune-tellers or horoscope-readers.

Karma is the doctrine that refers to one's state in this life as a result of actions (both physical and mental) in past incarnations, and action in this life can determine one's destiny in future incarnations. It is an impersonal law of moral cause and effect and has no connection with the idea of a supreme power that decrees punishment or forgiveness of sins.

Karmabhoomi is region of religious action or an epithet for Bharat, i.e. India.

Karmayoga or the 'discipline of action' is based on the teachings of the *Bhagavad Gita*. *Karmayoga* focuses on the adherence to duty (*dharma*) in an unselfish manner.

Katha is a religious story.

Kumbh is a pitcher.

Kumbh Mela (the Urn Festival) is a Hindu pilgrimage that occurs four times every twelve years and rotates between four locations, namely Allahabad, Haridwar, Ujjain and Nasik. Each twelve-year cycle includes one *Maha Kumbh Mela* (the great Kumbh Mela) at Allahabad, which is attended by

millions of people, making it perhaps the largest pilgrimage gathering anywhere in the world.

*L*addoos is a sweetmeat.

*M*ahabharata is a Sanskrit epic principally concerning the dynastic struggle and civil war between the Pandavas and the Kauravas in the kingdom of Kurukshetra about the 9th century B.C., and containing the text of the *Bhagavad Gita*, numerous sub-plots, and interpolations on theology, morals, and statecraft.

Mahadeva is another name for Lord Shiva.

Mahatma is used as a title of respect for a person renowned for spirituality and high-mindedness.

Mala is a garland of beads, also known as *japa mala* or a rosary in many traditions and used as an aid to prayer and meditation.

Mandir is a Hindu temple. It is usually dedicated to a primary deity and other deities associated with the main deity.

Mantras are mystic words used in ritual and meditation. A *mantra* is believed to be the sound form of reality, having the power to bring into being the reality it represents.

Maya is the power of a God or demon to transform a concept into an element of the sensible world.

Moksha refers, in general, to liberation from the cycle of death and rebirth.

*N*irvana is a state of supreme liberation and bliss, and is in contrast to *sanskara* or bondage in the repeating cycle of death and rebirth.

Niyamas are codified as 'observances' in numerous Hindu scriptures.

P*akora* is a type of Indian snack prepared by deep-frying gram flour and any vegetable.

Parikrama literally means the circumference of a structure, usually a temple. However, it normally refers to the act of circumambulating the inner shrine as an act of piety, such a circuit being regarded as a condensed tour of the Universe, with the deity being the still centre and creative pivot of that Universe.

Pariksha means a test.

Phalahar is a special meal prepared for eating on completing one's fast.

Phalahari chapati is a special bread freshly prepared without a cereal or salt to eat on ending one's fast.

Prana is the infinite matter of which energy is born. It is not, as is commonly misunderstood as being air, or the breath, of the human body. *Prana* is achieved (initially) from the control of one's breathing.

Prana pratishtha: A Hindu temple is a sacred place, endowed with divine energies and powers. At the heart of each temple lie the deities, to whom we bow and pray in worship. Why is it, though, that these statues, these idols are worshipped as God? How did they come to be infused with Divine characteristics? The answer is the *prana pratishtha* ceremony.

Pranayama is a way of expanding the *sukshma prana* within to which we have no direct access.

Prasad is both a mental condition of generosity, as well as a material substance that is first offered to a deity and then consumed with the faith that the deity's blessing resides within it.

Pratiksha is wait.

Prithvi is earth.

Puja is a religious ritual which most Hindus perform every morning after bathing and dressing but prior to taking any food or drink.

Puranas are religious scriptures that discuss devotion and mythology.

Puri is an Indian bread made from a dough of *atta* (flour), water and salt by rolling it out into discs and deep frying it in *ghee* or vegetable oil.

Raga *gopuram* is the gateway to a temple in south India.

Ramayana is a Sanskrit epic, traditionally attributed to Valmiki, that concerns the banishment of Rama from his kingdom, the abduction of his wife Sita by a demon and her rescue, and Rama's eventual restoration to the throne.

Rig Veda is the most ancient collection of Hindu sacred verses, consisting principally of hymns to various deities.

Rishis are sages or seers who heard the hymns of the *devas* (gods) and then wrote them down as Vedic scriptures.

Sadguru is the guru or God Himself manifesting in a personal form to guide the aspirant. To see the guru is to see God. His presence purifies all.

Sadhana means spiritual exercise in Hinduism. The goal

of *sadhana* is to attain *moksha* (salvation) to calm the mind or to obtain grace from God.

Sadhu is a common term used for a renown ascetic or practitioner of yoga who has given up pursuit of the first three Hindu goals of life: *kama*, *artha*, and even *dharma*. The *sadhu* is solely dedicated to achieving *moksha* through meditation and contemplation of God.

Samadhi is a state of deep absorption in the object of meditation, and the goal of many kinds of yoga. In Hinduism it signifies the highest level of mystical contemplation, in which the individual consciousness becomes identified with the godhead.

Sama Veda is third in the usual order of enumeration of the four *Vedas*, the ancient core Hindu scriptures.

Samiksha is introspection.

Sampradaya is a philosophy borne through history by verbal transmission. It is more inclusive than the related term *parampara*.

Samskaras or *sanskaras* are purificatory rites to be performed by a person during the rites of passage.

Sanatan Dharma (Hinduism) is the belief in monotheism where there is one Supreme God who pervades everywhere in all the universes. Sanatan Dharma is the dominant religion of India, where over 85 per cent of the population follows it.

Sanyasin or *sanyasi* is a renouncer who carries the heavy responsibility of preserving the *dharma* or the divine law of our tradition.

Satsang refers to the company of the highest knowledge

and truth; the company of a guru; contact with a person or an assembly of persons who listen to, talk about, and assimilate the truth. This highest company also takes the form of hearing or reading the words of highest awareness, reflecting on, discussing and assimilating their meaning, meditating on the source of these words, and bringing this awareness into one's daily life.

Sattva is the quality of purity or goodness; it is existence also.

Sattvic is pure.

Shakti is an aspect of *devi* or goddess and a personification of god as the divine mother who represents the active, dynamic principles of feminine power. Alternatively, *shakti* represents the power of God in Shiva's wife, who is Parvati.

Shraddha is one of the most central Hindu concepts — sacrifice and surrender through acts of worship — inner and outer.

Sri Guru Granth Sahib is more than a holy book of the Sikhs who treat this *Granth* (holy book) as a living guru.

Swarajya is self-mastery or independence.

*T*apasya is an act, that is generally self-inflicted and makes one endure tremendous difficulties to promote one's spiritual growth.

*U*panishads are speculative and mystical scriptures of Hinduism, regarded as the wellspring of Hindu religious and speculative thought.

Upvas is to abstain from food or abstain from certain

foods, especially as a religious discipline.

Vairagya signifies freedom from passion or disgust for worldliness because of spiritual awakening. It means leading the life of an ascetic or a monk.

Varna is the class system in which people are grouped according to their traditional job function.

Varnavyavastha is the class system among the Hindus.

Vayu is wind.

Vedas are religious scriptures that form part of the core of the Brahminical and Vedic traditions of Hinduism.

Vimâna is roofed temple stucture or shrine with more than one storey.

Yagna is a religious or spiritual ceremony performed by a Hindu priest in order to alleviate *karmic* difficulties and is generally the most preferred method to ameliorate a crisis situation or a dangerous, life-threatening period.

Yajur Veda is one of the four Hindu *Vedas*; it contains religious texts focusing on liturgy and ritual.

Yama was considered to have been the first mortal who died and espied the way to the celestial abodes, and in virtue of precedence he became the ruler of the departed. In some passages, however, he is already regarded as the God of death.

Yogi is one who practices yoga and has achieved a high level of spiritual insight.